OKANAGAN COLLEGE LRC

01071687

D0787352

Iberian Art

M. TARRADELL

OKANAGAN COLLEGE LIBRARY
BRITISH COLUMBIA

Iberian Art

53081

RIZZOLI
NEW YORK

Spanish-language edition:

© *1977 by Ediciones Polígrafa, S. A. - Barcelona (Spain)*

English translation published in 1978
in the United States of America by:

*R*IZZOLI *INTERNATIONAL PUBLICATIONS, INC.*
712 Fifth Avenue / New York 10019

All rights reserved.

No parts of this book may be
reproduced in any manner whatsoever
without permission of

*R*IZZOLI *INTERNATIONAL PUBLICATIONS, INC.*

Library of Congress Catalog Card Number: 77-39175
I.S.B.N.: 0-8478-0163-2

Printed in Spain by La Poligrafa, S. A. - Balmes, 54 - Barcelona-7 - Spain - Dep. Legal: B. 18.806 - 1978

CONTENTS

INTRODUCTION

On August 4, 1897, a group of Spanish peasants plowing a field at La Alcudia, near Elche (the site of an ancient Iberian, later Roman, town), unearthed a carved limestone female bust which they named the Moorish Queen. Although not an actual royal figure, the Moorish Queen, as is often the fate of real monarchs, was soon on her way to exile. Even though the local intelligentsia had quickly realized that the sculpture was an exceptional work of art, a famous French archaeologist had managed to acquire it before Madrid could officially intervene.

Carried off to France and exhibited at the Louvre, the Lady of Elche — the Queen's new name, by which she is still known — succeeded in arousing great curiosity and interest in an art that until then had been practically unknown: Iberian art.

The Lady of Elche added a new perspective to the history of western Mediterranean culture. Its spectacular discovery had occurred at the right moment, when Europe was beginning to develop an interest in art produced beyond its confines and, in particular, in dead civilizations. All kinds of aesthetic suggestions — from the art of Africa and the Far East to the cave paintings of the paleolithic era and the treasures of the Near East — were beginning to be accepted, whether they came from far-off countries or far-off centuries — even millennia. Everything has since been assimilated and become part of the creative force of a world that until then had been nurtured exclusively by its own tradition, having accepted from the ancient world only the heritage of Graeco-Roman art. The extraordinary adventure of modern art could not be fully explained without taking into account the tremendous impact that the recognition of non-European arts had on its genesis.

The discovery of Iberian art followed the same path, and the change that has taken place in very few years is significant. In fact, the Lady of Elche was not the first important piece to be discovered, even if it is still considered a great work of art. Already in 1870 a series of stone sculptures from a Spanish sanctuary known as Cerro de los Santos (Hill of the Saints) was discovered in the vicinity of Montealegre del Castillo, in the south-east of the province of Albacete. It was a very rich find, revealing an unknown aesthetic world, which Spanish experts immediately recognized as belonging to the Iberian civilization. The sculptures' international début, however, was a failure. The copies in plaster that were sent to exhibitions in Vienna (1873) and Paris (1878) met with a cold reception. The experts cast doubt on their authenticity, yet neglected to verify their origin because they didn't think it worthwhile. A quarter of a century later, the reaction was quite different: the atmosphere had changed, the capacity to understand had increased significantly.

The discoveries occurred at a time when, without reservation, they could be accepted as a new chapter in the history of art, a discipline that was then developing at extraordinary speed. The timing was right, because in art, as in science, *one only finds what one is looking for*. Just as the fruits of nature ripen at specific times of the year, so, too, cultural births or discoveries occur in cycles that essentially coincide with historical periods. Many examples of Iberian art had been discovered long before the Lady of Elche, but neither the scholars of the Renaissance nor the savants of the eighteenth century were prepared to appreciate them. Absorbed in their exclusive interest in classical art — the only form of art that moved them — they ignored Iberian masterpieces. This is not surprising when we consider the indifference with which, not long before Iberian art had begun to attract attention, the experts of the British Museum welcomed the reliefs of the Parthenon. Only by placing Iberian art in the context of contemporary trends can we explain the process of its discovery and appreciation.

It should be pointed out, however, that almost a century after its existence was acknowledged, Iberian art is still not as well-known as one would have expected. Even in Spain, where its presence should have achieved a certain popularity — at least among intellectuals or people aware of artistic trends — it remains a patrimony reserved to a few connoisseurs. Why? Essentially because there exists in those circles a certain inertia, a mental laziness that causes innovations to be accepted at a slower pace than they should be, even when trends are in their favor. So far, studies on Iberian art have been limited to the world of specialists, mostly archaeologists, since almost all the discoveries were made by them. As a result, there are practically no critical studies on Iberian art dealing with its aesthetic and stylistic aspects, only archaeological treatises concerned with chronology, influences, and the like. Moreover, in order thoroughly to understand the Iberian artistic phenomenon, it is essential to have a minimum of information about the people who created it. The time has passed when critics could attempt to analyze works of art without knowing the historical and social environment that produced them, as though the works were the products of human robots, detached from space, time or any socio-economic context. But what do educated men know today about Iberian civilization? Hardly anything. This is why we feel that in order to understand the art, we must devote some pages to the general aspects of Iberian civilization.

There have been different views of this matter. A few scholars, for instance, have disregarded leading archaeological theories and tried to solve the Iberian mystery by concocting a pastiche of carefully dosed references to Spanish baroque, tauromachy, Picasso, Dali, and, *en passant,* the great Castillian and Andalusian painters of the Hapsburg period.

The nuances of this "Hispanicism" are countless but surprisingly easy to export north of the Pyrenees; and within the country itself, they encourage the myth of *España eterna.* Needless to say, this kind of superficial explanation does not make the understanding of Iberian art any easier, in fact, it makes it impossible to understand anything at all.

TOWARDS AN UNDERSTANDING OF IBERIAN ART

As we have seen, the Lady of Elche, the sculptures from the "Hill of the Saints" and a few other works from the same period were the first discoveries that aroused an interest in Iberian art. However, some time was to elapse before the artistic patrimony of Iberianism, once recovered, could be appreciated and understood as a whole. After all, what could be the significance of a few isolated pieces? Until it became possible to study them in sufficient quantity and variety, evaluate their environments, verify their differences and corroborate their dates, our knowledge of Iberian art was no more than a prologue, the mere presumption of its existence. For three or four decades, during which more and more pieces were discovered, doubts and misconceptions were dispelled, but only gradually and often quite slowly.

Not long after the identification of the sculptures, several painted ceramics were discovered. This was not only a new step towards a more comprehensive knowledge of Iberian art, but also a highly significant discovery, since ceramics, by their very nature, are not an isolated phenomenon but one that is common to all ancient civilizations. These are objects which, unlike the large stone figures, were intended for everyday use. Precisely because they were so common, Iberian ceramics are available today in great number, permitting us to establish their original uses and giving us ample possibilities for study.

In the early years of this century, a considerable documentation on the styles and techniques of Iberian pottery was already available. This led only to confusion, because the excavations almost coincided with the sensational discovery of the Mycenaean civilization, and certain similarities between the decorations of the respective ceramics were observed. Inevitably, the exemplars discovered in the Iberian peninsula were at first described as imitations of Mycenaean art, a theory which some specialists rushed to confirm. Thus appeared Iberians who supposedly had existed *before* the first millenium B. C. It was not until 1915, when archaeologists unearthed Iberian ceramics lying side by side with Greek importations of the fifth and fourth centuries B. C. that the "Mycenaean hypothesis" was finally abandoned.

At about the same time, systematic excavations of Iberian villages, cities and necropolises were initiated. These afforded a more complete vision of a world until then known only through Greek and Roman texts and the isolated discoveries mentioned before. Iberian sculpture and ceramics were finally being studied in the context of the world that had produced them. It was the first notable progress since the excitement of the original discovery. Iberian art was no longer a heterogeneous collection of curious objects; it was beginning to achieve status as art in the history of pre-Roman civilizations.

New discoveries were made. After the stone sculptures came numerous small votive bronzes from the sanctuary of Sierra Morena and votive terracottas from the sanctuary of Serreta de Alcoy, and just before the Spanish Civil War, the sensational discovery of the ceramics of Liria, a collection enriched in recent years by the excavations of Alloza, in the valley of the Ebro River.

During those years research progressed but, as often happens, it was not particularly well organized. What could be called "the crisis of Iberianism" — a result of the typical dichotomy of Spanish archaeological research — occurred in the 1940s, a time when there were almost as many funds available as there are now. One group, acknowledging the strong impact that the Indo-European culture had produced on the population of the peninsula, tended to minimize the distinct personality of Iberian civilization. The other, with equal prejudice, considered Iberian creations much more recent than they actually were, envisioning the Iberian phenomenon as the result of Roman influence on the indigenous population, and Iberian art, as nothing but a facet of Roman provincial art, whose local roots gave it a certain originality but no more.

However, this turned out to be a passing phase. There soon came a reaction against what we now realize was one of those trends that appear from time to time in all fields of research and, supported by recognized authorities, are followed until someone proves the inaccuracy of their premises. Around 1950 a total re-evaluation of Iberian art began to take place. It was established that it was a phenomenon unrelated to any concept of race but rather the product of a civilization whose origins could be traced to pre-Roman times and, more specifically, to Greek colonialism. Iberian art, therefore, may be considered truly autochtonous, even though the inspiration may have come from the eastern Mediterranean. We shall discuss Iberian civilization in our next chapter, but first let us briefly take inventory of what we mean by Iberian art.

ARCHITECTURE

At present, our knowledge of Iberian architecture is so limited that it would be presumptuous on our part to include it in this essay on Iberian art. The buildings of the villages and towns so far explored are utilitarian and generally quite modest, not to be

compared with the beautiful, original creations of the sculpture and painted pottery. We do not know whether there were public, religious or private buildings of any importance. As for the sanctuaries, the ones we know seem to belong to cults whose rites were related to their natural surroundings, that is, were celebrated in caves, grottoes or on mountaintops. The actual constructions, when they existed, were small and, judging from surviving foundations, aesthetically insignificant. Iberian society responded more to ancient naturalistic myths than to the idea of the temple as an essential part of the *polis,* the city as conceived by the Greeks or by ancient Oriental civilizations. True Iberian temples, then, hardly exist, or at least none has been found so far; and if Iberian religion did not inspire any monument worthy of the name, it is not surprising that there are no public buildings either, considering that in antiquity the first large buildings to be erected were usually the temples.

With few exceptions, funerary architecture, too, is practically non-existent. The rites of cremation and of individual burial — as was the practice among the Iberians — certainly didn't require monumental tombs. Only in some villages of Andalusia do we find funerary chambers vaguely reminiscent of Etruscan tombs; but there is little to be noted there, except the technical sophistication of their masonry. Sometimes a few isolated elements — capitals or fragments of decorations — suggest that perhaps one day, with new excavations, architecture will be included among Iberian arts. For the moment all we can offer are theories, although the most recent discoveries — among them the remains of the Pozo Moro tomb — do not disprove them, as has been suggested in certain quarters. These remains hardly belong to a large building but rather to a mausoleum with a roughly square ground-plan, whose sides are merely four meters long.

SCULPTURE

Iberian sculpture falls into two categories: large, often monumental stone figures and statuettes in bronze and terracotta. Monumental sculpture — depicting either human figures or animals — seems to have been a phenomenon limited to the south, an area approximately delimited by the Júcar River, though a few examples, such as the Bull of Sagunto, were found in the north. As we have seen, most of the human figures were discovered at Elche (the ancient Ilici), and at the sanctuary of Montealegre del Castillo, which yielded a rich series of female figures — some of them life-size — representing goddesses, priestesses or bearers. Besides these, a few other statues were discovered in Andalusia (in the outskirts of Seville) and in Albacete, and in the last few years some additional pieces — all funerary sculptures — have been excavated, confirming how much our information on Iberian art depends on new archaeological finds. The most important of these sculptures is an almost life-size seated female figure, with a head-dress reminiscent of the Lady of Elche's. It was found in the necropolis of the ancient city of Basti, the modern Baza (Granada), which earned it the name of Lady of Baza. Subsequently, in a mausoleum discovered at the site known as the Corral de Saus de Mogent in Valencia, several recumbent female figures were found, followed by a series of very unusual reliefs from the mausoleum of Pozo Moro in Albacete, which have not yet been thoroughly studied or written about. Finally, while these lines were being written, news came of the discovery of numerous sculptural fragments in the neighborhood of Porcuna (Jaén).

It should be pointed out that, apart from the fact that these finds add considerably to the existing patrimony of Iberian art, they support the established chronology: the sixth century B. C. for Pozo Moro and the fourth for the Lady of Baza.

The animal figures are scattered throughout a wider area, and include lions, bulls and other real as well as mythological animals that are impossible to identify. The religious connotations of these pieces are clear, but in most cases we lack enough data to assign to them any specific function. Some may have belonged to sanctuaries; others were probably erected by the roadside or even used as milestones.

Aesthetically, human figures and representations of animals, both real and fantastic, belong to the same world, revealing the best in the artistic and technical characteristics of Iberian art. There are no doubts about their common origin; their creators achieved in both an extraordinary liveliness of expression with techniques that are simple, even naive but not without the subtle refinement typical of primitive art. This is probably what most appeals to us now, when we look at them with eyes jaded by centuries of artistic endeavors. The similarities to archaic Greek art, so often mentioned by scholars, have recently been denied, and in the last two or three years, a theory suggesting neo-Hittite influences, presumably transmitted to the Iberians through the Phoenicians, has been formulated. This hypothesis is based on the above-mentioned reliefs of Pozo Moro and on the analysis of various characteristics of the animal sculpture. Could this lead once again to another kind of inflation, to a new fashion? The truth is that not all is imitation. Many of these works are the product of a spiritual and social

background that is not far removed from the Greek world of the seventh and the sixth centuries B. C. Ultimately, then, it is better not to rely entirely on the comparative method of research, useful in many cases but misleading when it fails to take into consideration the very roots of a cultural phenomenon.

This does not hold true for the small sculptures of the same period. For one thing, they were intended for a much wider public, and thanks to the excavations conducted in the sanctuaries of Sierra Morena, near Despeñaperros, Castillar de Santisteban, and Collado de los Jardinos, are now available in great quantities. For several centuries worshippers continued to deposit their votive offerings — almost always bronze statuettes. But despite the fact that there are so many, it is difficult to study them in depth, because they are scattered among countless museums and private collections. However, we know that these statuettes continued to be manufactured over a long period of time with little stylistic change, the latter depending less on chronology than on the different workshops or craftsmen that produced them. Some achieved real quality but others are little more than rudimentary male figures. Some of them, judging from their praying posture, can be described as worshippers; others look more like horsemen.

Though most of the known bronzes come from the two centers mentioned, some of the smaller ones were found in similar sanctuaries, such as La Luz, near Murcia, or those scattered around eastern Andalusia, especially in the province of Jaén, where the two previously mentioned centers are located.

In the same places where the bronze statuettes were discovered, a few ones in terracotta were also unearthed. But so far the only large find of them has been made in the village of La Serreta, near Alcoy, where today it represents one of the attractions of the little local museum. It consists of a rich collection of small, mostly female figures, some of which show a strong Mediterranean — Greek or Punic — influence, while others are the product of a cruder but no less expressive indigenous art. As in the case of the bronzes, the terracottas were brought to the sanctuary as votive offerings, but they don't seem to have the emblematic value of the bronze gift bearers, which usually symbolized the divinity worshipped in the sanctuary.

Iberian terracotta sculptures were found all along the Mediterranean coast and farther north than any of the stone figures, though in much smaller quantities. The pieces found in Catalonia resemble the most primitive of those discovered in Alcoy, but again, in very small and heterogeneous lots.

PAINTING

Another important facet of Iberian art is painting. We are not sure whether murals existed or how prominent they were — the buildings examined so far are not encouraging in this respect. Therefore, when we speak of Iberian painting, we are referring essentially to painted ceramics. There are numerous examples of them, and they seem to have had mostly utilitarian functions. People unfamiliar with archaeological excavations are usually surprised by the abundance of pottery — most of it painted — found in Iberian villages.

The decorations follow three different styles. The first, exclusively geometric, usually consists of a few horizontal bands, with occasional concentric semi-circles or spirals. Although remarkably elegant, this type of decoration is quite simple and of little pictorial interest. Found throughout the Iberian territory — from Languedoc to western Andalusia — it is also the oldest, having flourished between the fifth and the third centuries B. C. but lasting virtually unchanged until the extinction of Iberian culture.

The second style consists of decorations alternating geometric with floral designs — especially leaves — and figures of animals, mostly birds and wild beasts' heads. Some portray winged female figures, probably representing local goddesses. They are static, often rampant, heraldic-looking figures, which confirms the religious origin of their imagery. They reveal a powerful and accurate technique and a compulsion to decorate every inch of the background with various secondary motifs. The result is a certain baroque effect, though not as strong as in the next group. This style is typical of the south-east, and is called Elche-Archena, from the sites where the most characteristic examples were discovered.

The third and most recent style, which developed in Valencia and, on a smaller scale, in Aragon, Murcia and Catalonia, includes mostly friezes of hunting, war, or dancing scenes, often accompanied by inscriptions. After years of controversy, it is now agreed that it developed relatively late, and that all the pieces we know date from the second and first centuries B. C., when the Romans had already occupied the country but hadn't yet imposed their culture, and the Iberian world was to a large extent still intact. Apart from the importance of their inscriptions as a source of information about the customs of the period, and from the excitement the inscriptions inspired in philologists attempting to decipher the Iberian language, these vases occupy a prominent position in the history of Iberian art and represent one of its most evocative aspects. The

best-known are those from a village on the hill of San Miguel, near Liria, in central Valencia; but ceramics found elsewhere in Valencia — La Serreta de Alcov, Oliva, Benidorm — prove that the style spread over most of the region as well as in some parts of Aragon.

METALWORK

Iberian jewels and other metalwork are less spectacular and abundant, especially since we cannot include among them such treasures as the finds of Aliseda (Caceres) or El Caramboro (Seville), which belong to the Tartesian rather than to the Iberian world. In the case of more recent pieces, another kind of question arises: whether these were imported or manufactured locally. But apart from these cases there is no doubt that there existed Iberian gold and silversmiths who created tableware, jewels (in the style of Greek and, in part, Phoenician and Etruscan prototypes) and various bronze ornaments. To these we might add the coins, minted in silver and bronze, obvious imitations of Greek and Roman pieces but preserving the indigenous custom of decorating both faces of the coin.

IBERIAN CIVILIZATION

At this point we ask ourselves: Where was this art born? Who were these Iberians who created it? What did Iberian civilization really consist of? First, we should remark that only recently have scholars begun to recognize it as the most original and noble of all the pre-Roman cultures that flourished on the Iberian peninsula. We already have seen how Iberian art was at first thought to be of Mycenaean origin and, more recently, to be a form of Roman provincialism — a mistake of more than one thousand years! For a long time, too, people surmised that the Iberians originated from Africa, and we could enumerate many other specious theories distorting the phenomenon of Iberianism. Naturally, several historical problems remain to be solved, some of which are particularly relevant to us as they closely relate to art. But we can safely say that the general outline we possess today is correct and cannot be disproved by future research, whose major role will be limited to filling the various lacunae.

Another point that should be cleared up at once is the very idea of Iberianism. Misled by a simplistic vision of history, in which invasions seem to produce radical changes in a conquered country, we tend to think more of changes in people than in civilizations. If contemporary history were to be explained this way, in a few thousand years it could be summed up with something like: "Then the bearers of the industrial revolution took over, in turn conquered and replaced a century later by the invaders of the cosmic-atomic era." In reality, what matters are the innovations generated by each new civilization, not the changes brought about by invasions. This is why since prehistoric times the basic ethnic characteristics of geographical regions have changed very little while the respective societies have undergone such profound transformations.

Iberian civilization followed the same process. It was born not because new people arrived either from Africa or from anywhere else but because in the first millennium B. C. Phoenician and Greek sailors and colonizers established a bridge between the more advanced countries of the eastern Mediterranean and the "underdeveloped" ones of the west. As a consequence of these external stimuli, the natives of the Iberian peninsula eventually transformed their lifestyle and society by incorporating the novelties they had assimilated in their own fashion. For the moment, we hardly know how the process of assimilation occurred; but we *do* know its result: Iberian civilization. It extended throughout the area where the population had come in direct contact with the Phoenicians, the Carthaginians and, above all, the Greeks, i.e., the Mediterranean coast from Andalusia to the Languedoc, with a few extensions to the hinterland: south-east of Meseta

(Albacete) and, thanks to the accessibility of the valley of the Ebro, as far as Navarre.

As a result, the Iberians developed into a society that was much more sophisticated than the civilizations that had preceded them. Their settlements were larger, and some already deserved the name of city. They had their own written language and were beginning to adopt a monetary system; they used iron regularly, and were familiar with such advanced techniques as the potter's wheel.

We are not talking here of mere copies: Iberian civilization had its own distinct personality. We may call it derivative but by no means a cultural province of the Greek or Phoenician-Carthaginian worlds. Iberian identity is unmistakable and clearly defined; so are its geographical nuances, for Iberia never was a political unit. The social nucleus of the Iberians was the city, a rather small group of buildings that would hardly be considered a city these days, yet it resembled the *polis* of archaic Greece and was not much different from the cities of most Mediterranean countries of the classical period. Each group of cities — or, better, villages — constituted a tribe. The territory controlled by each tribe varied considerably in extent. The southern tribes, for instance, occupied much larger portions of land. They included the *turdetanos* and the *bastetanos,* who lived in western Andalusia; the *mastienos,* in the region of Murcia, and the *contestanos* in southern Valencia. Central Valencia was the home of the *edetanos,* with the *ilercavones* occupying the north, including the delta of the Ebro. The *ilergetas* — who dwelt farther north in the plains of Lérida and in what is now the province of Huesca — and the *indigetas* of the Ampurdan district were relatively large tribes. The others, such as the *cosetanos* from Campo de Tarragona and the *laietanos* from the plain of Barcelona-Valles-Maresma, were much smaller. The *lacetanos* lived a little farther inland; the *bergistanos,* in the Berguedán district. The demarcations of these territories were never clearly defined nor were they always the same, but in general they coincided with natural borders and more or less correspond to present historical-geographical regions.

It is not easy to determine exactly what distinguished these tribes from one another, that is, whether the differences were political or had a much deeper significance. In either case, a few broad distinctions can be safely made. There was a southern Iberian world — rich and sophisticated — whose art was represented primarily by sculpture, and a northern one, less progressive, whose boundaries more or less coincided with the course of the Júcar River. Also, the tribes of the coast were more open to foreign

influence and significantly more developed than those living in the mountains, which were not only less receptive but also lived on poorer land — all circumstances that were reflected in their respective societies.

There were ethnic differences as well. In Catalonia and Aragon, for instance, the numerous infiltrations of Indo-Europeans through the Pyrenees during the previous centuries had deeply affected the populations in the north but barely left a trace in Valencia. The combination of regional and local differences and common experiences is precisely what constitutes the complexity of Iberian civilization, a subject that cannot be discussed in depth here, not only because of lack of space but also because many basic problems have still to be solved or have been solved only in part.

One of the most typical and most enigmatic aspects of the Iberian world is the language, whose interpretation was delayed by the problems presented by the writing. The Iberian system consists of a combination of alphabetical and syllabical signs. The vowels and some consonants, such as *m, n, r,* and *s,* are expressed by letters, as in any alphabetical system, but the Iberians also had symbols representing syllables — *ba, be, bi, bo, bu; pa, pe, pi, po, pu; da, de, di, do, du; ta, te, ti, to, tu; ga, ge, gi, go, gu;* and *ka, ke, ki, ko, ku.* This peculiar coexistence of an archaic element — the syllabic — and a more progressive one — the alphabetic — caused great difficulties in deciphering Iberian inscriptions. But even when these difficulties were overcome around 1920, and scholars finally were able to read Iberian, they still could not translate it, since they did not know the meaning of the words themselves. At present one thing is clear: Iberian sounds very ancient, very strange to the ears of people used to Indo-European idioms.

Interestingly enough, even before scholars tried to read the original inscriptions with the aid of the toponymy derived from classical sources, the possibility that Iberian and Basque could be the same language was advanced. This theory was popular for a few years, but recently, despite the fervor of its supporters, it has lost most of its credibility. Yet there are between the two languages certain similarities that do not warrant a total rejection of the Basque-Iberian hypothesis.

The problems could be easier to solve if we knew more about the origins of the Iberians. As we have mentioned earlier, it seems certain that this civilization was born from the influence of colonizers on the people living along the coasts of the peninsula. But such an assertion, though substantial compared with the nebulous theories advanced in the past, is nevertheless incomplete, because we don't know exactly how this influence took place. There are two possibilities. One, that Iberian civilization developed throughout the area that came directly in contact with the Greeks and the Phoenicians. This implies that, at the time of colonization, all pre-Iberian people of the coast had a somewhat common background — which cannot be proved.

On the contrary, we know that at the beginning of the first millennium part of this territory (Catalonia and Aragon) had been deeply affected by the Indo-Europeans, while the south managed to preserve the ethnic and cultural tradition of the Bronze Age. The other possibility is that there existed an initial center of Iberianism, which could be regarded as the cradle of this civilization and as having eventually expanded to the other areas of the Iberian world.

All considered, we tend to agree with the second hypothesis. If this is so, and an original center indeed existed, it must have been in the south — in Andalusia, to be precise — because the birth of Iberianism cannot be separated from the fascinating and still enigmatic history of Tartessos.

The Tartesians seem to have developed immediately before and in the same area as the Iberians. Theirs was a rich, autochthonous culture with strong Oriental characteristics, which originated in western Andalusia (between the valley of the Guadalquivir and the province of Huelva), the result of Phoenician influence between the eighth and the fifth centuries B. C. For the moment, much less is known about the Tartesian civilization than the Iberian, despite the classical references, which afforded the first clues to its identification, and the many important discoveries made in recent years. It is quite possible that more surprises are in store, and that one day the mystery will be solved. But for the moment, what seems relevant is the similarity between the two civilizations and their geographical proximity, which confirms the southern characteristics of major Iberian works of art.

THE SOCIOLOGY OF IBERIAN ART

Practically nothing is known about the artists who created the Iberian sculptures so far discovered. The few Graeco-Roman sources that give any detail of Iberian society make no reference to the existence of a local art. As for Iberian texts, we have already mentioned that they are untranslatable, and even if they should ever be deciphered, it is doubtful that they could hold any surprises. Naturally, given the times and the society, the works are not signed, and it is conceivable that, at least at the beginning Greek sculptors participated directly in the establishment of the school and the style. Considered second- or third-rate at home, and having already worked in the Greek colonies of the west, these artists probably settled in Iberian territory in search of a new clientele. A plausible explanation, yet these must have been sporadic cases, since most Iberian sculpture appears to have been the creation of local artists. Even if Iberian art cannot be explained without the Greek precedent and stimulus, it has a clearly autonomous, indigenous character. In fact, rather than from direct influences, the similarities arise from the fact that socio-economic and environmental conditions of archaic Greece and of Iberian society were much closer than it would seem. On the other hand, the obvious unity of style and concept in Iberian statuary seems to confirm that the authors were itinerant artists who made the rounds of the areas where the works were found. Also, Iberian sculptures are clearly not improvised. The technical resources may have been limited, but the sureness of execution and the ability to create expressions with a few simple lines exclude any kind of improvisation. Behind each Iberian statue there is a tradition, a craft, probably even a workshop, even though the sculptors who created the larger works had a very limited clientele. We have not reached this conclusion on the basis of the pieces available today, since these represent only a small percentage of the actual production, and many were lost through the centuries. One must consider that, unlike Graeco-Roman art, lovingly collected since the Renaissance, the appreciation of Iberian art is very recent. Besides, fewer Iberian urban centers have survived than Roman cities in the west; most have become "fields of solitude," "desolate hills," as they would have been called during the Renaissance. In other words, Iberian sculptures were discovered in the countryside, beyond the reach of learned or curious people with an interest in preserving them. Finally, we must keep in mind that very few excavations were carried out in the centers where Iberian art actually flourished. Countless pieces are probably still buried, awaiting the moment when the archaeologist's pick or some lucky chance will unearth them and restore them to the artistic patrimony of mankind. It is also true that the production of statues was limited because the demand was limited. Only in the great sanctuaries and in the large urban centers such as Elche, the "Hill of the Saints" and one or two other Andalusian towns, the rate of production could have been sufficient to support one or more permanent workshops. Under such circumstances, it is difficult to imagine that sculptors should have lived in the towns where their works have been discovered. Most likely, the artists had no permanent residence, and travelled to the places where their services were required — rather as the sculptors of the Middle Ages did. This nomadism is even more plausible if one considers that the area in which Iberian art developed was small; and travelling, relatively easy, even taking into consideration antiquity's different concept of distances.

The absence of a centralized power, of established monarchies and truly organized cities prevented the formation of a rich clientele of courtiers and municipalities. Moreover, the modest scope of Iberian architecture did not allow sculpture to develop — as in other ancient civilizations — in the field of decoration of monuments. In this respect, Iberian society was very different from those of Egypt, the Near East or Greece, where one of the main functions of sculpture was architectural. As far as we know, Iberians were unlike their predecessors and contemporaries of the eastern Mediterranean.

Given such conditions, there can have been only a few Iberian sculptors, trained in a few centers, from which they travelled for brief periods of time to where their work was needed. This thesis is more realistic than to assume that large, heavy statues could have been carried to their destination from some hypothetical workshop. This seems particularly true for sculptures of animals, since these are scattered over a wider area than that of the human figures, and frequently appear to be either the only exemplars or one of the few discovered in a single place.

Why Iberian monumental statuary disappeared so soon, long before the end of Iberian culture, is still a mystery. That a well-established art, with a specific social function — in this case, religious — should die leaving hardly a trace, while the society that created it survived without essential variations, is very unusual. We know today that Iberian sculpture was at its height in the fifth, the fourth and part of the third centuries B. C. It is true that around the middle of the third century there were major upheavals in a large part of the territory due to a Carthaginian invasion, later followed by the Roman conquest of the entire peninsula. But it is also true

that the Iberian world remained practically intact in its internal structure; and as we have mentioned in the introduction and as we shall see in discussing the sociological aspects of Iberian painting, the other facets of its society and its art fully confirm this thesis.

It is not surprising, therefore, that the dates of Iberian sculpture should have been the subject of lengthy arguments among specialists. Only since archaeological evidence based on sound stratography has become available, have we known with any certainty the date of its beginning. More important, we know that when the painting on ceramics was at its height, the monumental sculpture had already disappeared. It is quite possible, of course, that some of the figures of gift bearers on the "Hill of the Saints" belong to a later date, but this could be an exception, due to a custom of that particular sanctuary or to a local tradition. Yet little is known in detail of the chronology of the pieces from the "Hill of the Saints." Even if one day, after a definitive study of these scupltures, our theory concerning their survival should prove true, we would still ignore the reasons for the decadence of Iberian sculpture.

It is a decadence that cannot be linked to a stylistic decline; quite the opposite. Iberian sculpture had shown no sign of deterioration; there was not the slightest warning of its imminent collapse. The best proof lies in the fact that we cannot determine, from their style, whether any of the statues belong to the final period, because we know nothing about the latter's characteristics. When the end of the artistic cycle came, Iberian sculpture was no longer produced.

Death must have come from the outside, then, interrupting the normal course of the artistic cycle. The causes that destroyed Iberian sculpture were social — perhaps the disruption of war or a change in the structure of the government or the clergy. We don't know, except that the Iberians, after the great crisis of the Second Punic War, continued to thrive for two hundred years under the political domination of Rome, yet no longer produced monumental stone sculpture.

From the social point of view, painting presented a very different aspect. We refer, of course, to painted ceramics — practically the only form of Iberian painting, and almost certainly the only known form of painting that was produced in considerable amount. Given the rudimentary character of Iberian architecture and its lack of monuments, it can be assumed that, as far as architecture was concerned, what affected sculpture also affected painting.

Besides hypothetical murals and examples of painted ceramics, all we have are paintings on stone urns found in the necropolis of Galera, which were probably applied also to wooden objects that have since disappeared.

As a rule, painting on ceramics has always been a craftsman's activity, even in those countries where it attained the highest quality, such as Greece or, more precisely, Athens at the time of the famous red and black vases. We should not be influenced by the aesthetic criteria of the last two or three centuries. The humanistic tradition and the influence of museums and collectors have conditioned us to consider the painted vases of Greece precious works of art, which indeed they are. But at the time they were manufactured, the vases were just household vessels, which could be purchased at reasonable prices by Greek citizens, then at the height of their economic development, as well as by the "barbarians" of the farthest Mediterranean countries. If this was true for Athenian vases and for Greek wares in general, all the more reason to apply the same criterion to Iberian terracottas.

When an Iberian village is excavated and through the position in which the objects are found the household they belonged to can be reconstructed. It is obvious that painted vases were for common use, not reserved for the exclusive use of the upper classes but available to most social strata. Except for the kitchenware, almost all the pottery used in Iberian households was painted; the styles differ, depending on the period and the area in which they were found. Even the great urns from the village of San Miguel de Liria, where the most famous Iberian paintings come from, were just functional vessels, used for holding liquids, probably water.

The popular quality of this art is confirmed — beyond its domestic purposes — if we analyze its creative development. Naturally, by popular art we don't mean a non-professional activity handled by laymen but rather a production intended for the masses, in this case the farmers who constituted the greater part of Iberian society in the eastern section of the peninsula.

The impulse to decorate the smooth surfaces of vases was common to all Iberian people, and it appeared as soon as the technique of the potter's wheel was introduced. Painted ceramics soon became an industry, limited, of course, but the product of a workshop nevertheless, very different from earlier hand-made pottery, almost exclusively done by women ever since the neolithic civilizations had begun to use clay jars. The potter's wheel created a previously unknown centralization of

production and a uniformity of shapes and decorative motifs.

At the beginning, and for at least two hundred years, pictorial decorations were exclusively geometric, in most cases plain horizontal bands. The technique is quite simple, for it consists of holding a color-soaked brush onto a rotating vase. But while in other contemporary societies, such as the Phoenician and the Carthaginian, the decoration never went beyond a few simple bands, Iberian potters combined geometrical with floral and zoomorphic motifs. Shortly afterwards, the human figure appeared, usually in the form of narrative scenes.

Presently, Iberian painting reached its full maturity. But, as we have already seen, only in the regions of Valencia and Murcia, with a few examples in Aragon, in the central area of the valley of the Ebro, and in Catalonia did it reach this status.

Ever since the systematic study of Iberian ceramics began, it was observed that the paintings were executed in two major styles, which were named after the places where the works had been discovered: Elche-Archena in the south and Oliva-Liria in the north.

The Elche-Archena style shows greater precision of execution and a more formal composition, combining mythological animals — such as winged goddesses, wild-beast-like monsters, rampant eagles — with floral and geometrical motifs but almost without human figures. The human figure, on the other hand, is quite prevalent in the Oliva-Liria large narrative friezes, often filling the entire surface of the vase, and are sometimes accompanied by as yet untranslated inscriptions, which presumably allude to or explain the various scenes.

Recent discoveries have widened the areas of both types of painting, especially the second, but in general the distinction between them is still valid, although no one, so far, has attempted to explain the social background of either. We ourselves tend to believe that there was a significant socio-economic difference between the southern and the northern groups. In the case of Elche we are dealing with a real city, situated in a fertile plain on the coast, easily accessible by land as well as by sea. A genuine urban society must have existed there, with a rather complex internal structure, though much looser than the one found in Andalusia, where the monarchy and aristocracy exerted great pressure upon the population. Such a society favored an elegant, refined and somewhat restrained type of painting — a "bourgeois" painting, so to speak. The presence of human figures was not tolerated, and it

was only towards the end, when the influence of Rome was beginning to undermine the spirit of Iberian society — and therefore of its art — that the first human motifs appear, such as the face on the front of "La Pepona," a vase from Elche.

In the Iberian colonies further north the situation was different. We can hardly speak here of real towns; rather of villages huddled on hillsides, usually far from the coast. These rural communities produced a more popular, almost rustic kind of painting, a distinction that seems more valid than the one based on tribal divisions. Consider, for example, that while both Elche and La Serreta belonged to the same tribe — the *contestanos* — the pictorial style of La Serreta resembles that of Liria (Edeta, as it was then called), the capital of the *edetanos*. Likewise, the paintings of Oliva, which was the home of the *contestanos,* show obvious stylistic similarities to those of Liria.

Should we include in this study the art of Sagunto? We hesitate, since there are hardly any remains of what once was a famous Iberian city and one of the most important centers of the *edetanos,* making it difficult to place Sagunto within the framework of a predominantly rural society. If these premises are correct, and if the lack of painted ceramics in the narrative style is not simply the result of our lack of documentation, we may be justified in thinking that Sagunto did not adopt that style precisely because it escaped the rural environment that influenced the pictorial art of other *edetano* centers.

The further away we go from the sea — the highroad of civilization — the stronger the contrast becomes. Despite their similar subject matter and the style conceived within the same stream of inspiration, the difference between the painting of Liria and that of Alloza is quite clear. The primitive elegance found in the city of the *edetanos* is lost in the valley of the Ebro and is replaced by a kind of crude expressionism whose only charm is its spontaneity and naivete.

Many shallow theories have been advanced regarding the baroque quality of this art, but no one has ever mentioned what seems obvious to us: Iberian northern art developed in the same way and for the same reasons as those peasant arts — from early Greek ceramics to the works of Slavic craftsmen of the last few centuries — that are free to evolve independently from the artistic productions of other social classes and from the influence of court and city. With all their differences, as in the two cases just mentioned, the tendency towards narrative decor-

ation may well be common to several cultures. After all, what else is the typical "historical relief" of Roman sculpture but a sophisticated version — further refined by Hellenic influence — of the narrative painting of the *edetanos*? Here, too, we are dealing with people — the Romans — who preserved their original peasant outlook for centuries.

No examples of this art are found in Andalusia, and it is unlikely that any will ever be discovered there. In the second and first centuries B.C., the southern regions of Iberia were already too deeply inpregnated with Roman influence for an indigenous art to survive. And we cannot overlook the fact that in the ancient territory of the *turdetanos* (which the Romans called Betica and which corresponds more or less to the modern Andalusia) the Romans imposed their language more rapidly than anywhere in the peninsula. In fact, we know for sure that a large part of the Andalusians spoke Latin even before the time of Augustus.

But this is true only in part. To explain the absence in Andalusia of a popular art similar to that of Valencia, Aragon and, to a lesser extent, Catalonia, one must consider the difference in social structures. Stifled by the aristocracy, the peasants in the south could not express themselves artistically with the same freedom enjoyed by the lower classes in the east, where society was not so rigidly stratified. The popular art of Andalusia is known to us mainly through the bronze votive statuettes found in major sanctuaries. But these can hardly be considered a form of folk art. In the first place, they were made of bronze, a medium in which technique is the principal feature and does not permit as much freedom as painting on ceramics. More important, in purchasing those statuettes to lay them before the altars as votive offerings, the worshippers were striving to approximate the prototypes of *official* religious art represented by the large stone figures of sacred animals, gods and offering bearers — in other words, the art imposed by the feudal classes and the clergy since the beginning of Iberian culture.

On the other hand, the style of the bronze statuettes remained static, showing very few variations over a long period of time, since they were mass-produced from consecrated molds, and were still manufactured during Roman times. Hence the difficulty of dating these bronzes, which caused major controversies among experts whenever they tried to determine their exact chronology.

In the case of La Serreta de Alcoy it is important not to confuse the statuettes of the sanctuaries with the much freer creations of the painted ceramics. These were used by the very same people who deposited the votive offerings before the altars, but were quite different, that is, painted in the typical peasant style of the two great Valencian tribes — the *contestanos* and the *edetanos*. The statuettes of the sanctuary, on the other hand, reveal two different orientations. One was classical — Greek or Punic — adopted by the clergy, eager to incorporate a refined, exotic art in the cult, consistent with their background of Mediterranean syncretism, of which the Iberian religion was probably one of the westernmost manifestations. The other freely expressed popular feeling in doll-like figurines that look as if they had been molded by children. And while it is true that they have the charm of all naive creations, it is precisely their lack of technique that reminds us of the neolithic idols of the eastern Mediterranean — not such a far-off world, despite the chronological gap — and of the agricultural, pre-industrial civilizations of any race in any era. But the popular success of Iberian painting has a completely different meaning: it is an art revealing a distinct personality that cannot be compared to any other. It belongs to a definite people, time and place.

ILLUSTRATIONS

1. Votive offering in stone, from the sanctuary of the Cerro de los Santos, Montealegre del Castillo, Albacete. National Archaeological Museum, Madrid.

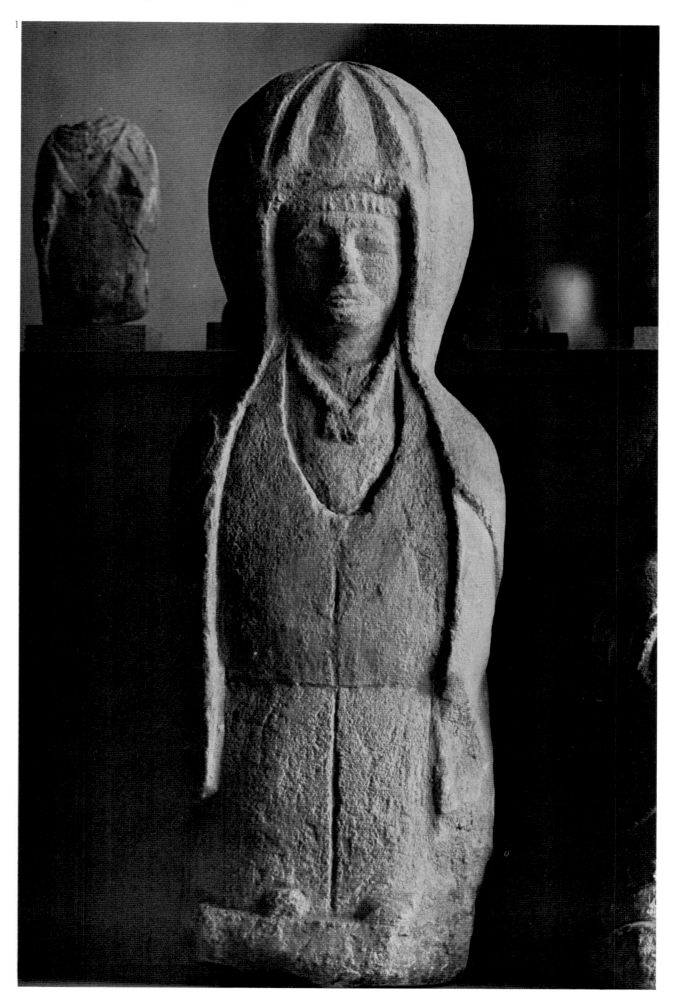

2. Head of an offerer, from the Cerro de los Santos. National Archaeological Museum, Madrid.

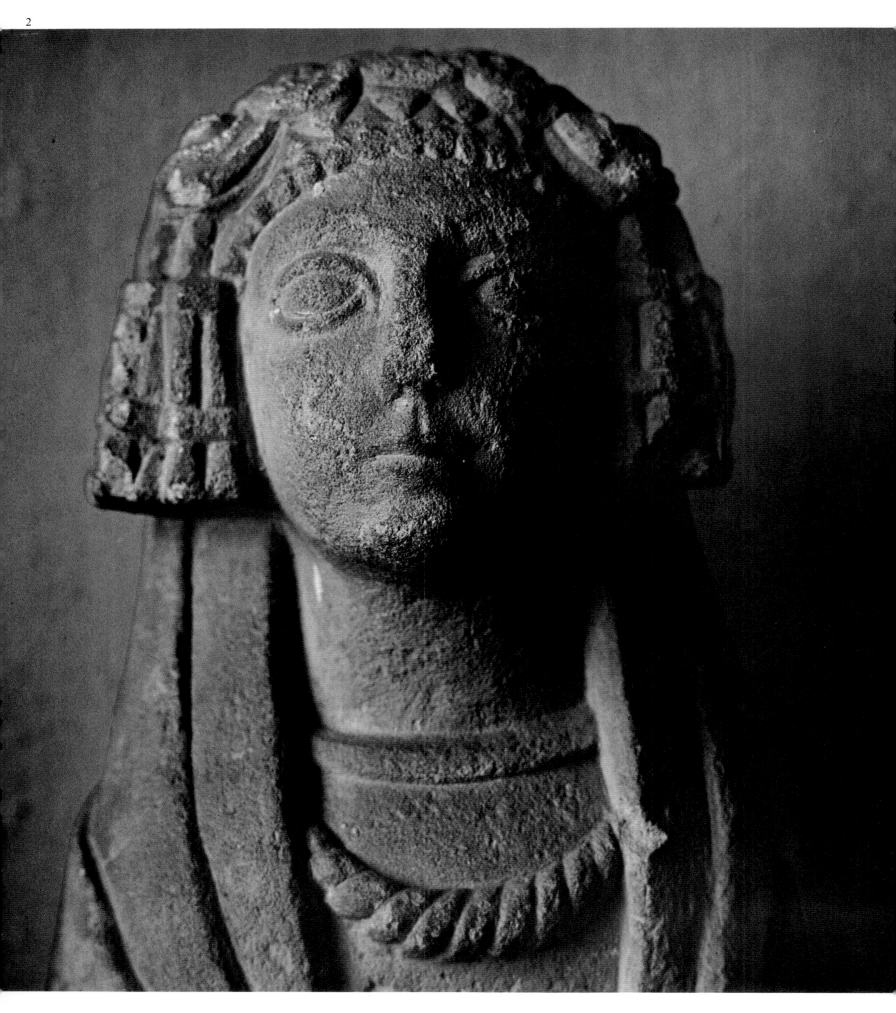

3. "The Lady of Elche," detail. Local limestone, polychrome. (Height 56 cm.) 5th-4th centuries B.C. National Archaeological Museum, Madrid. See also Fig. 88.

3

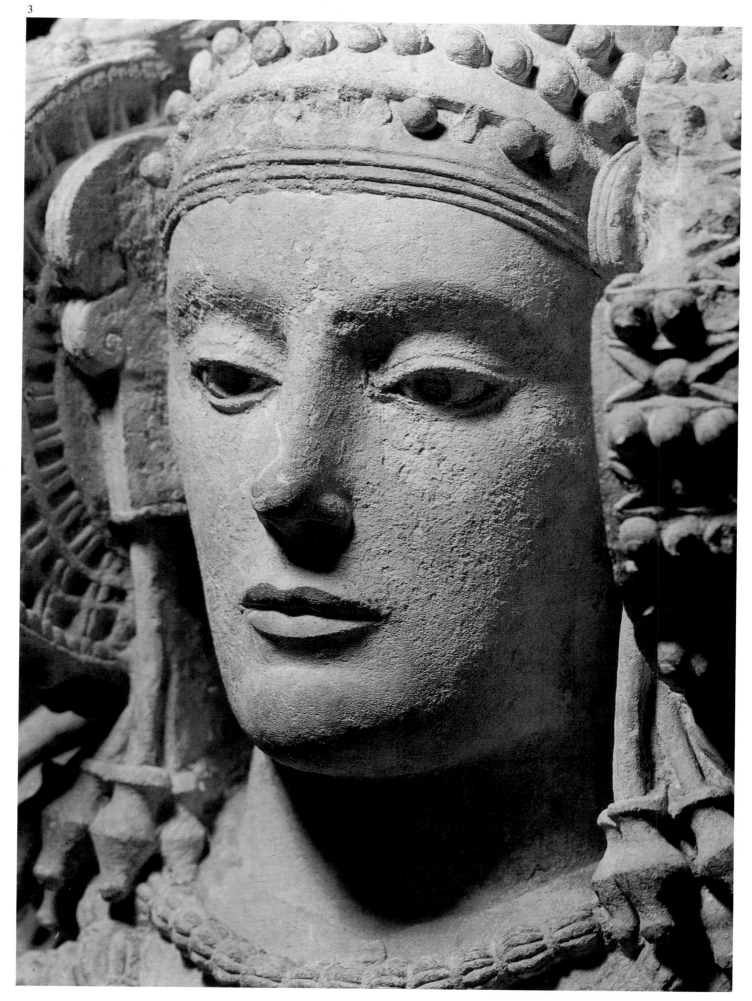

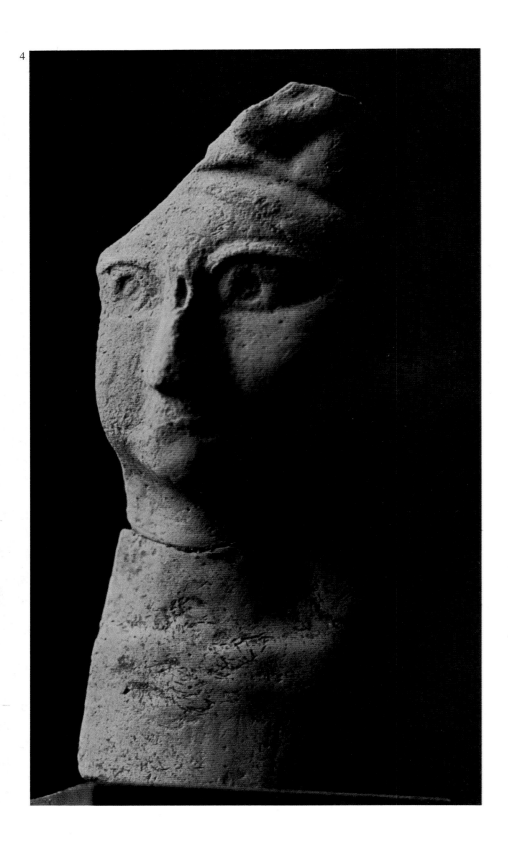

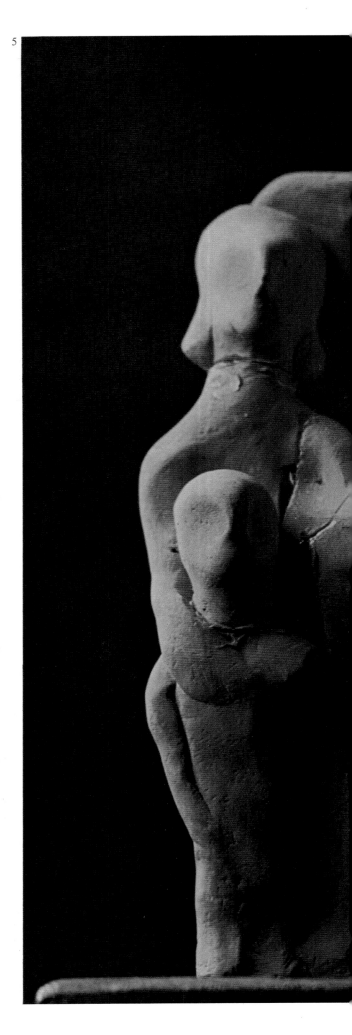

4. Terracota figurine from the sanctuary of La Serreta de Alcoy. Last derivations of Iberian art, lingering on into the period of the Roman Empire. Museum of Alcoy.

5. Group in terracotta, representing a goddess-mother with two children in her arms, flanked by a mother and child on one side and two flautists on the other. 2nd century B.C. Recently discovered in the settlement of La Serreta de Alcoy. Museum of Alcoy.

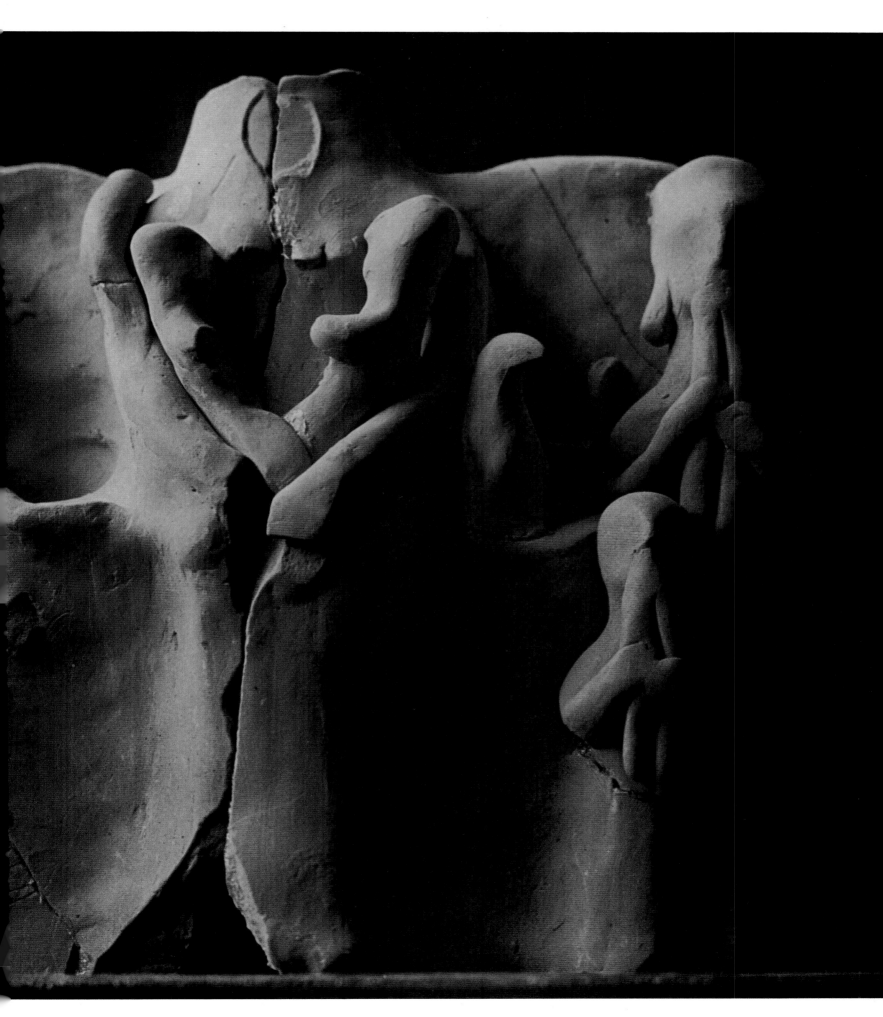

6. Head in stone. Cerro de los Santos. Archaeological Museum of Barcelona.

6

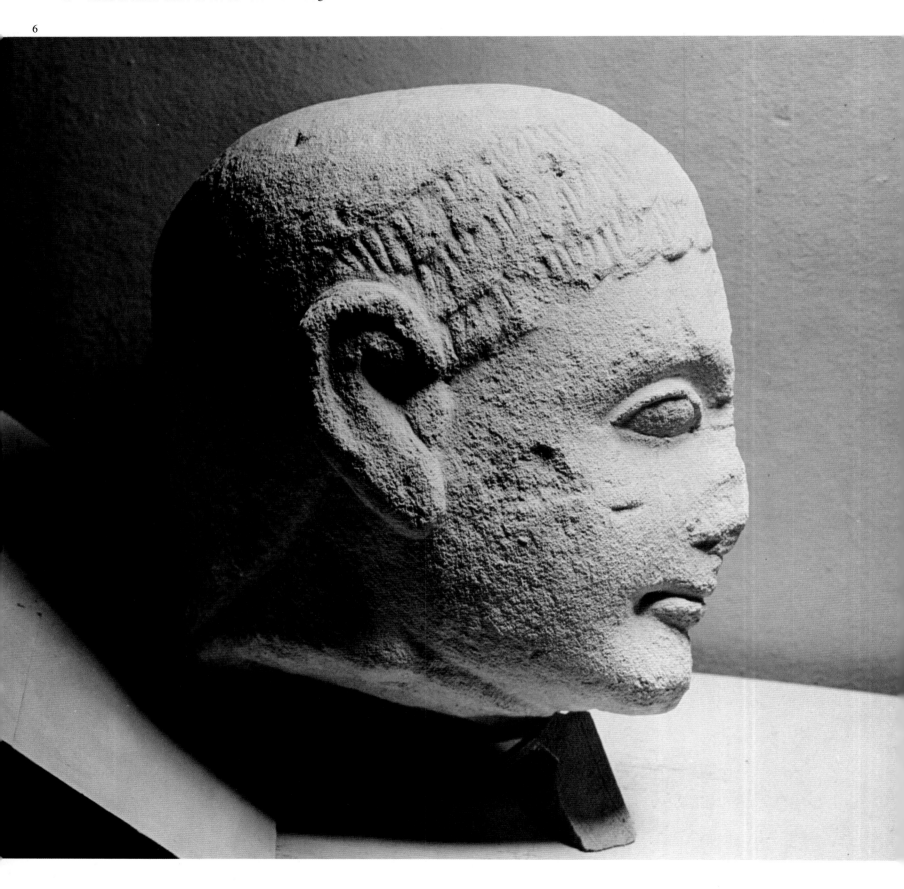

7. Stone griffin. 5th-4th centuries B.C. La Alcudia de Elche. Ramos Folques Collection.

7

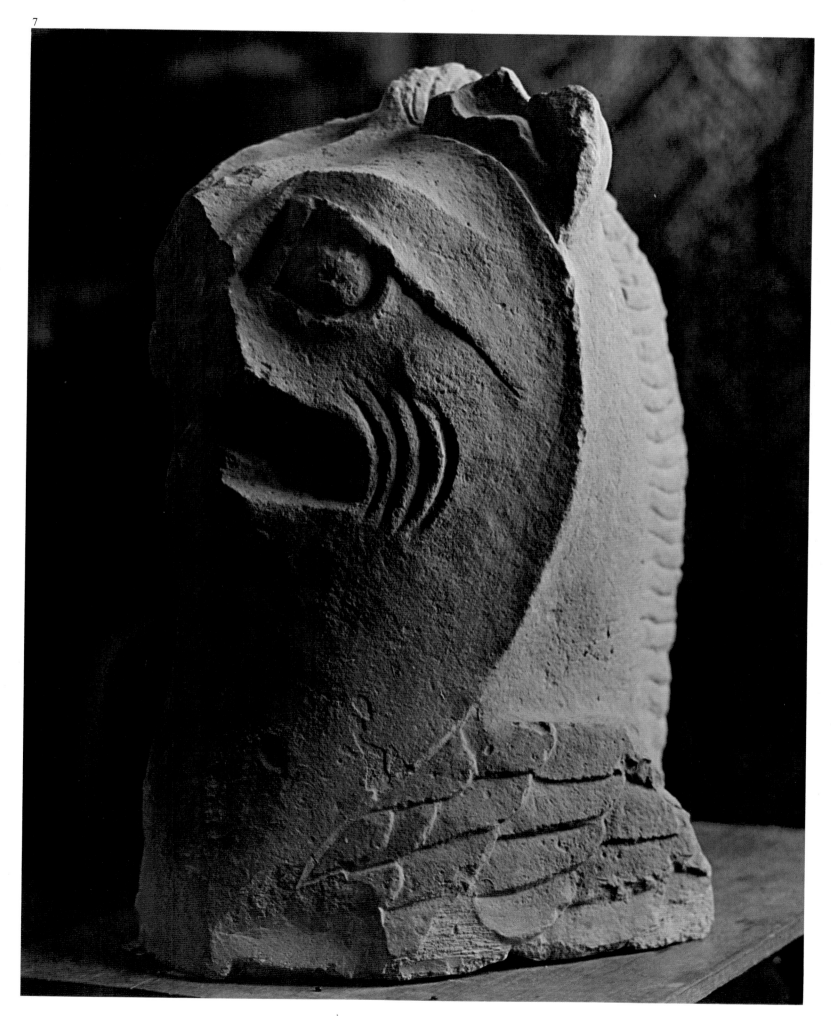

8. Orant. Bronze figurine from the sanctuary of Castillar de Santisteban, in the province of Jaén. Archaeological Museum of Barcelona.

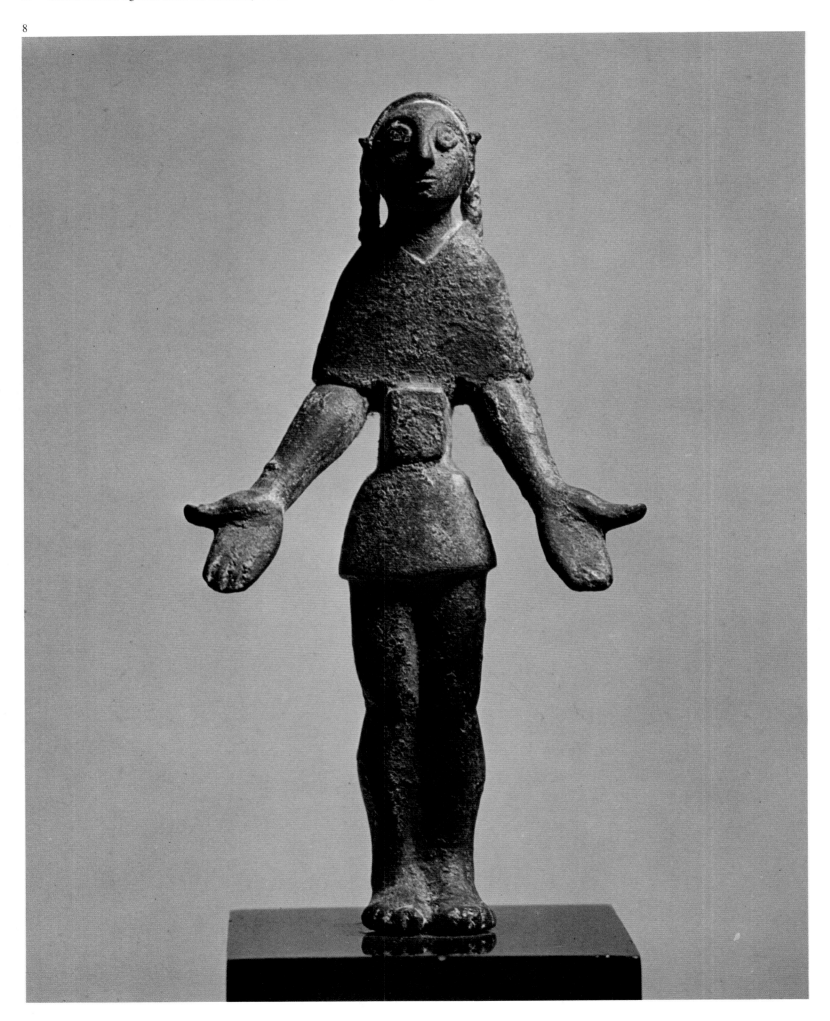

9. Small male head in terracotta. Sanctuary of La Serreta de Alcoy. Museum of Alcoy.

9

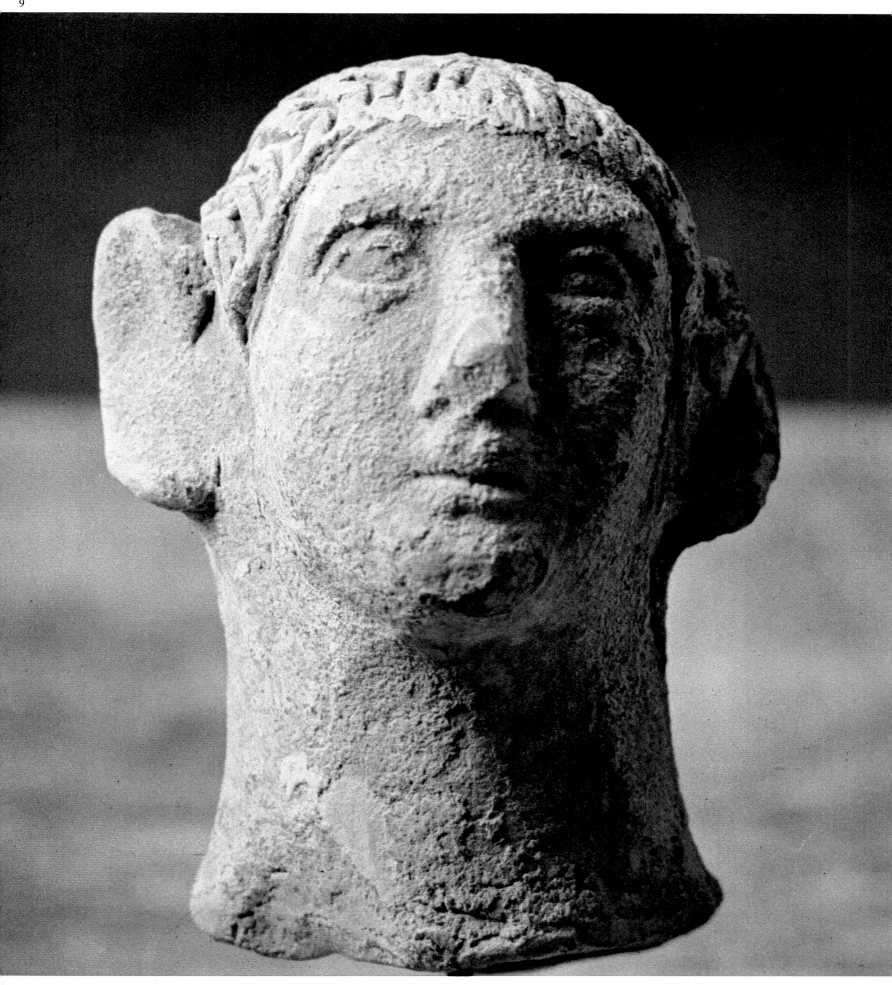

OKANAGAN COLLEGE LIBRARY
BRITISH COLUMBIA

10. Lion's head in stone. From Manga, Granada. Archeological Museum of Cordova.

10

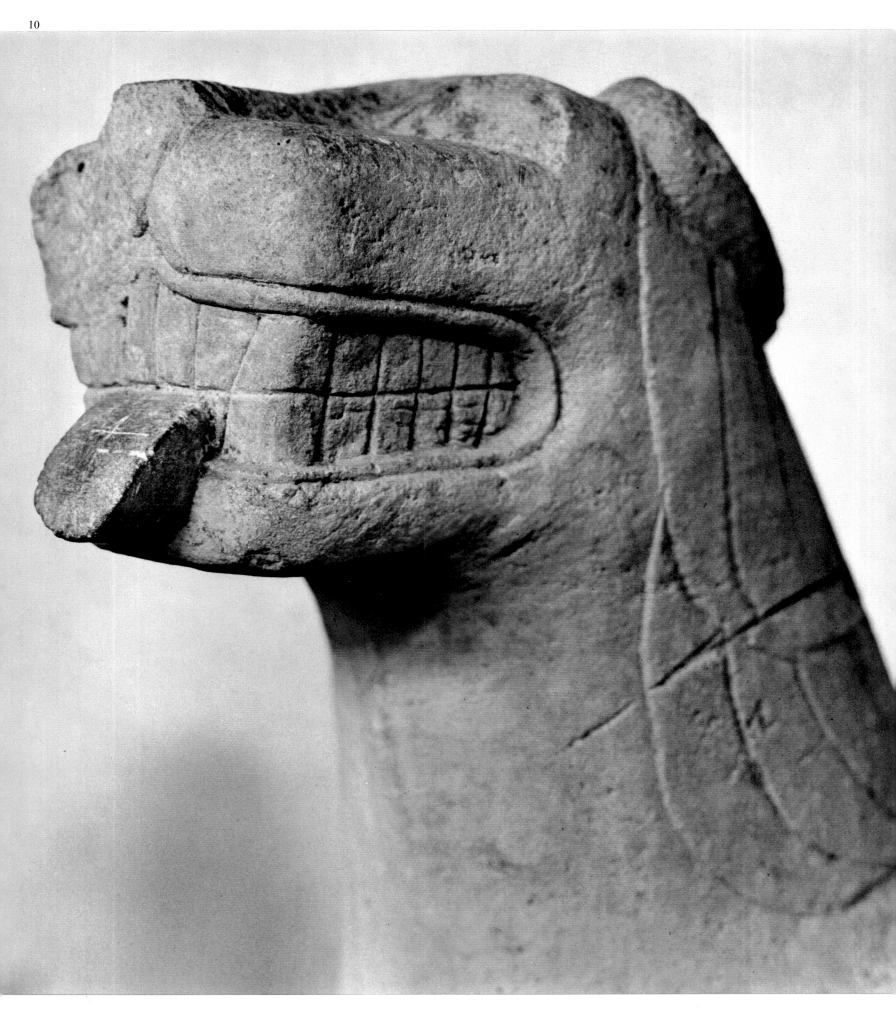

11. Figure in terracotta, from the sanctuary of La Serreta de Alcoy. Museum of Alcoy.

11

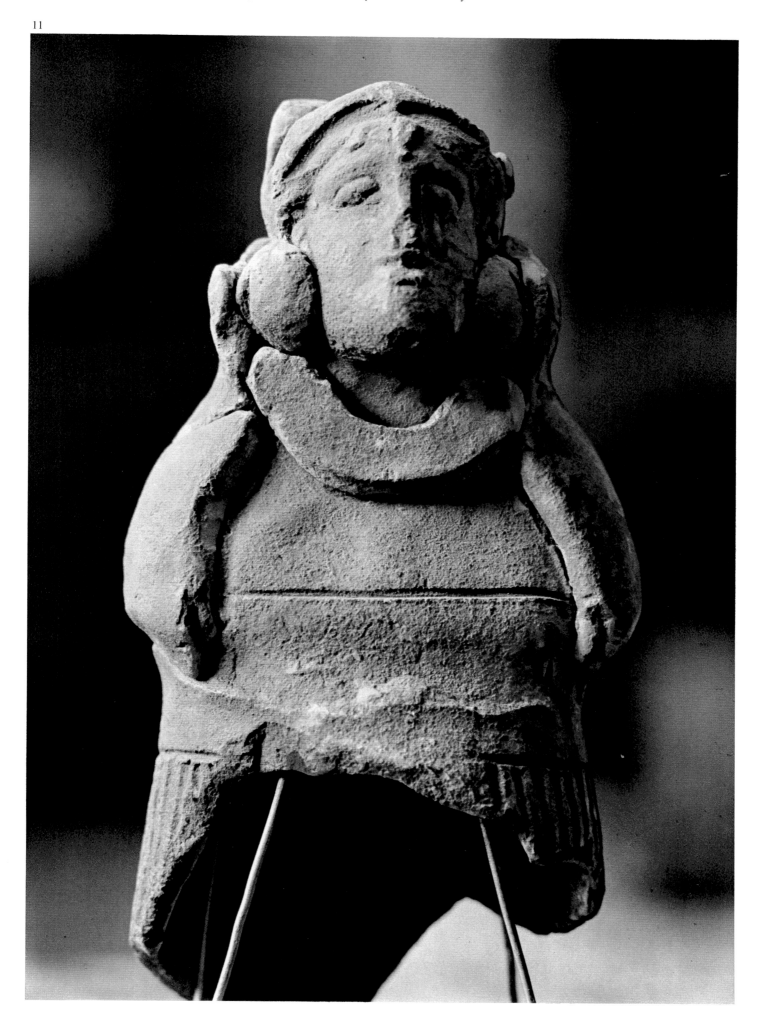

12. Offering figure of a lady, from the Cerro de los Santos. National Archaeological Museum, Madrid.

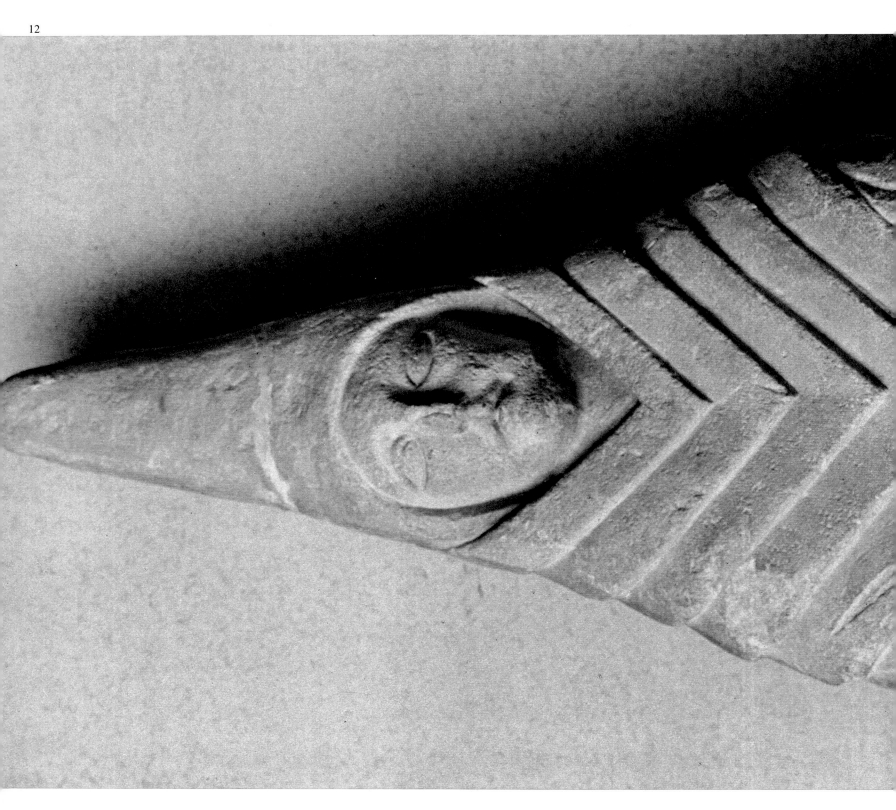

13. Torso of a warrior, 5th-4th centuries B.C. Sculpture in stone, discovered in La Alcudia de Elche. Ramos Folques Collection, Elche.

13

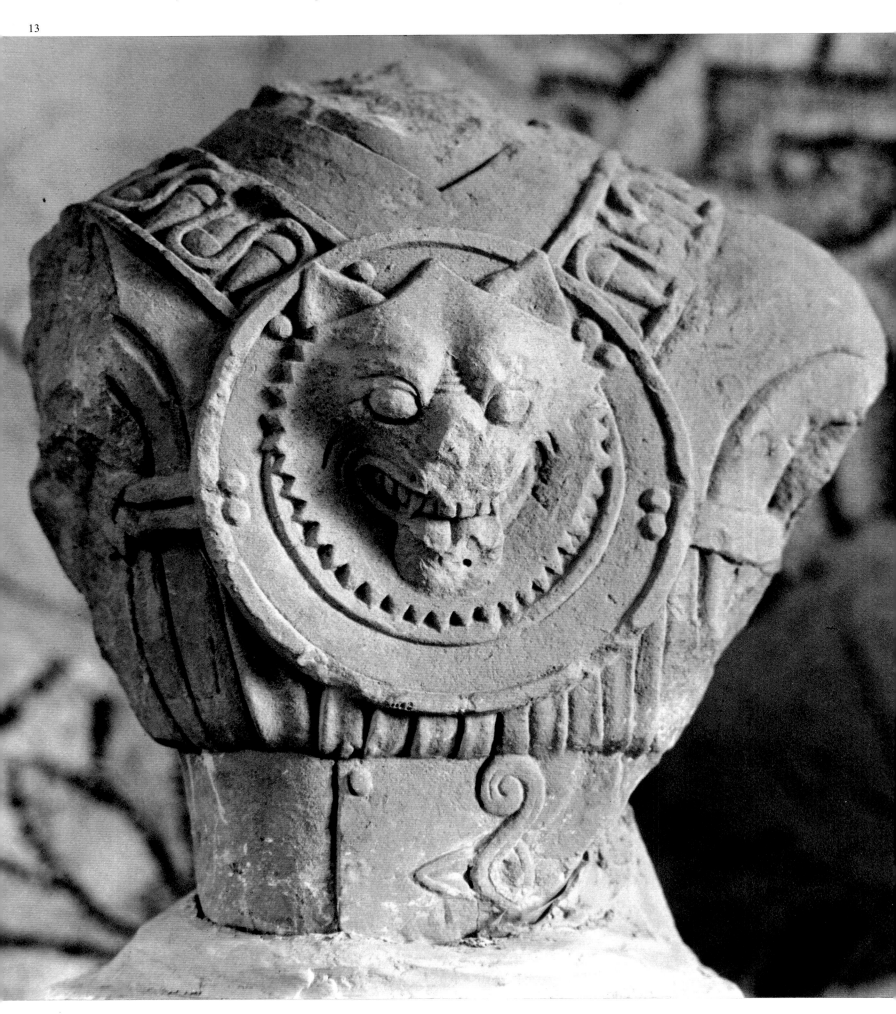

14. Detail of a fragment of stone sculpture, representing a warrior: a hand holding up a shield, 5th-4th centuries B.C.
La Alcudia de Elche. Ramos Folques Collection, Elche.

14

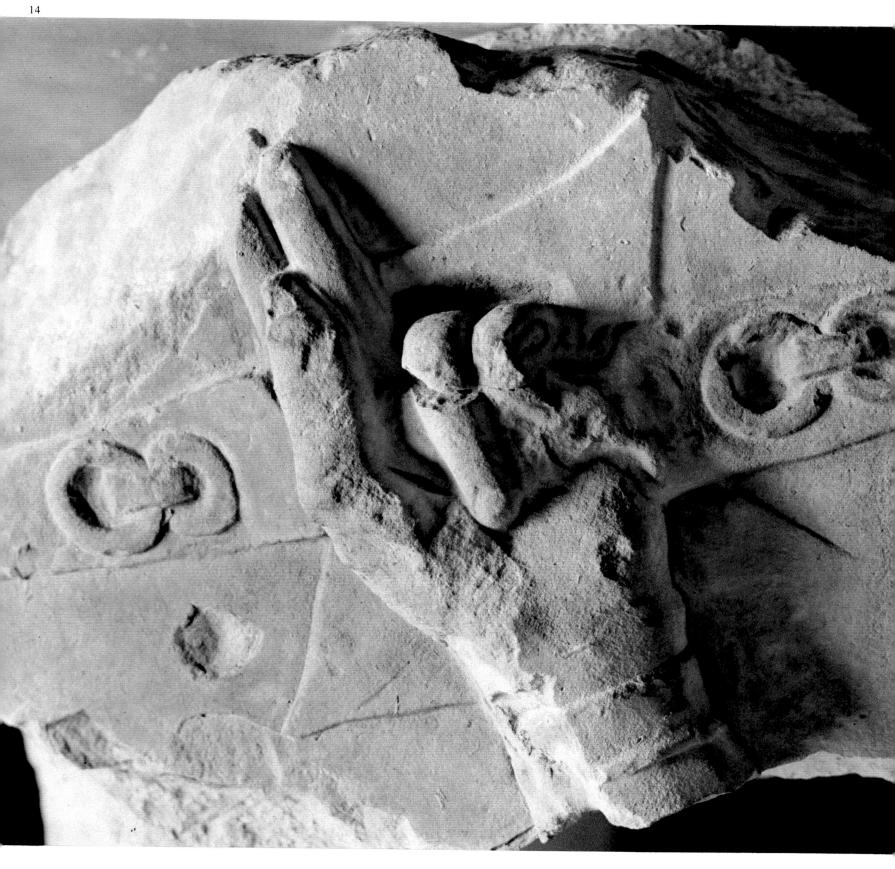

15. Horse's head. Detail of a votive offering from the sanctuary of El Cigarralejo de Mula, Murcia. Emeterio Cuadrado Collection, Madrid.

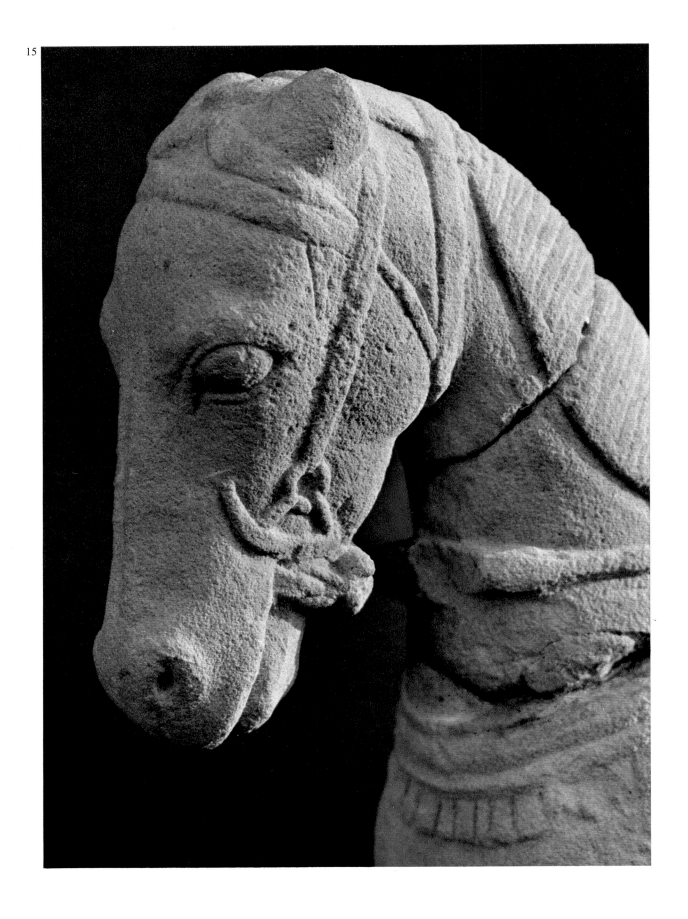

16. Horse. Relief in stone, from the sanctuary of El Cigarralejo de Mula, Murcia.
 Emeterio Cuadrado Collection, Madrid.

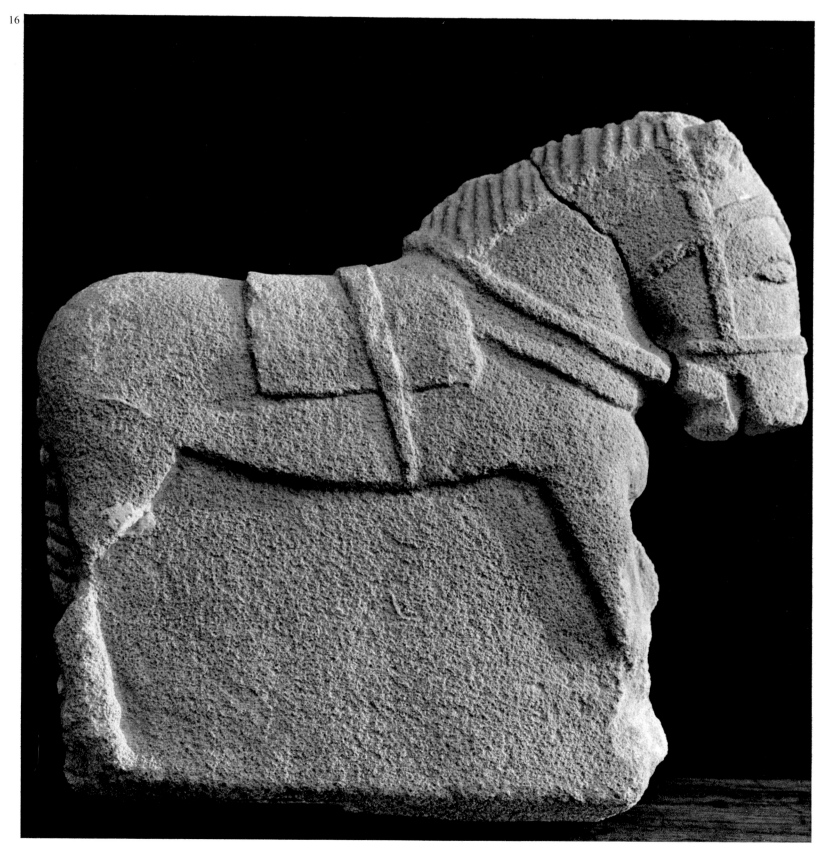

16

17, 18. Two aspects of man's head.

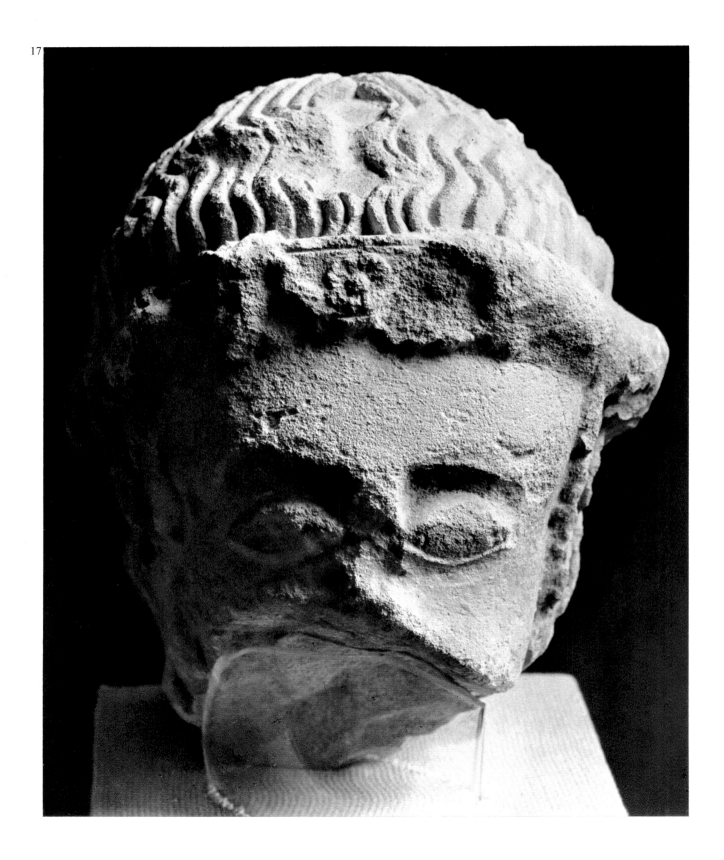

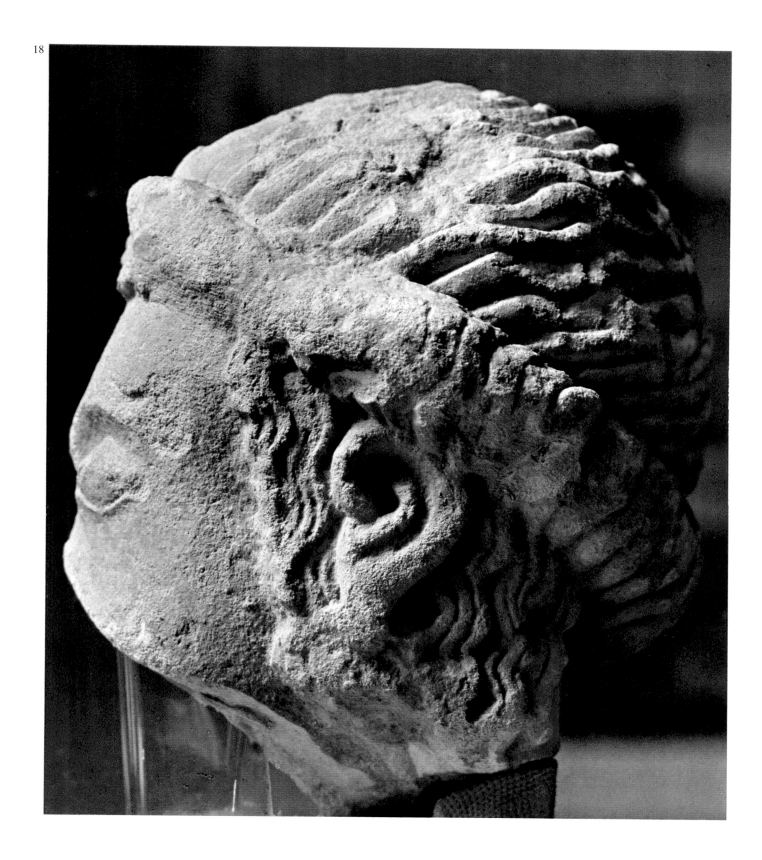

19

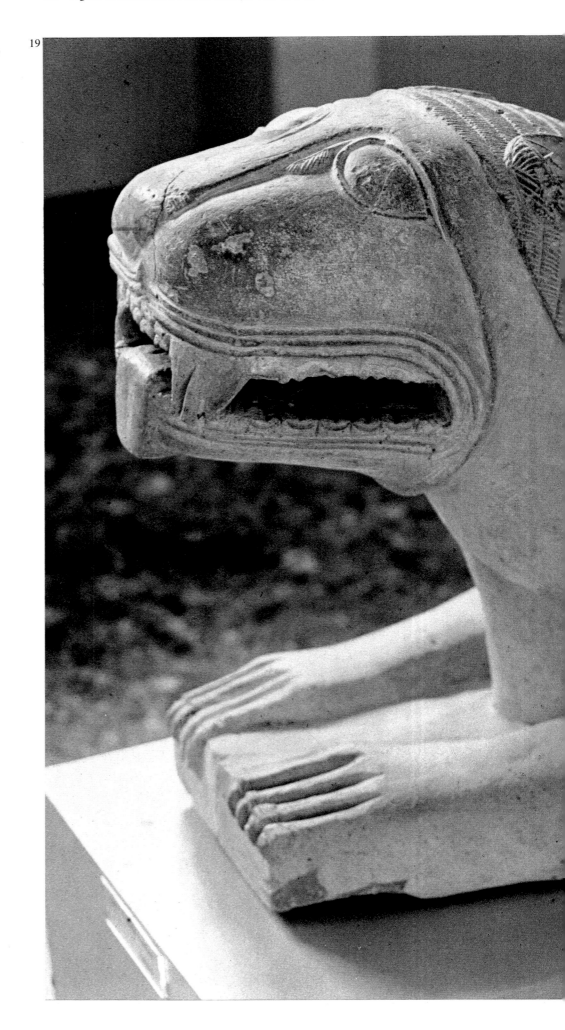

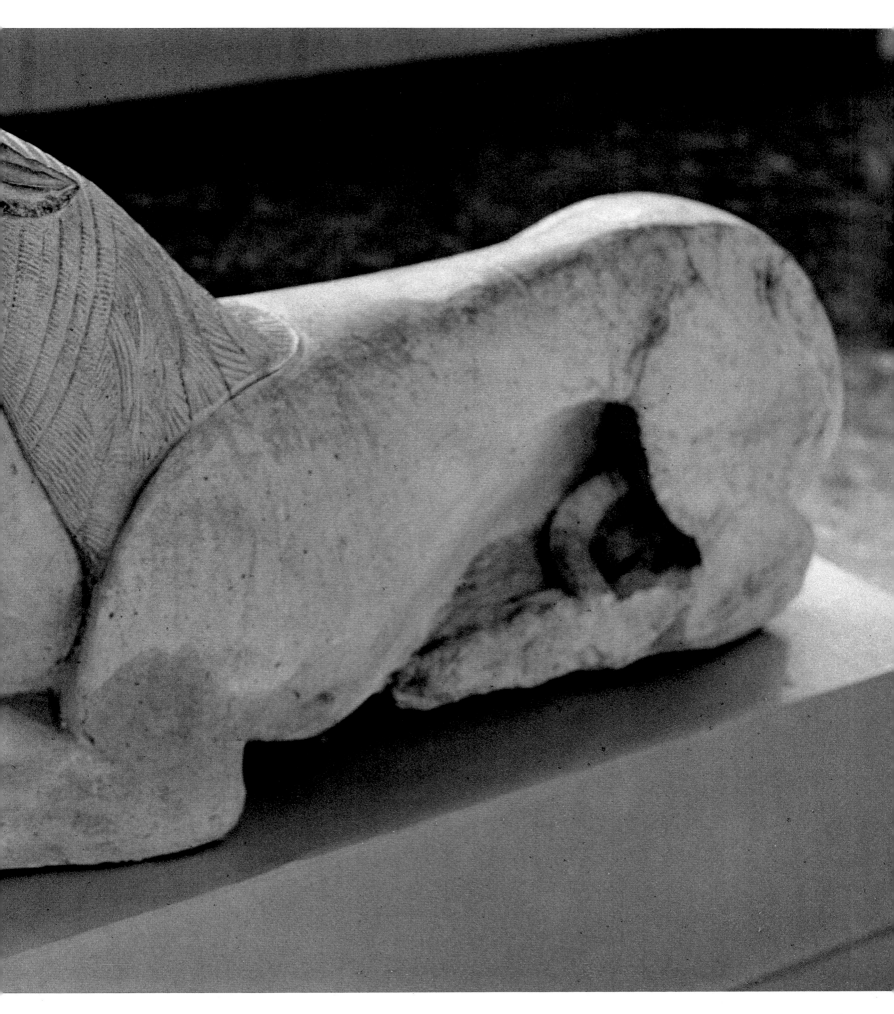

20. Asses. Reliefs in stone from the sactuary of El Cigarralejo de Mula, Murcia.
 Emeterio Cuadrado Collection, Madrid.

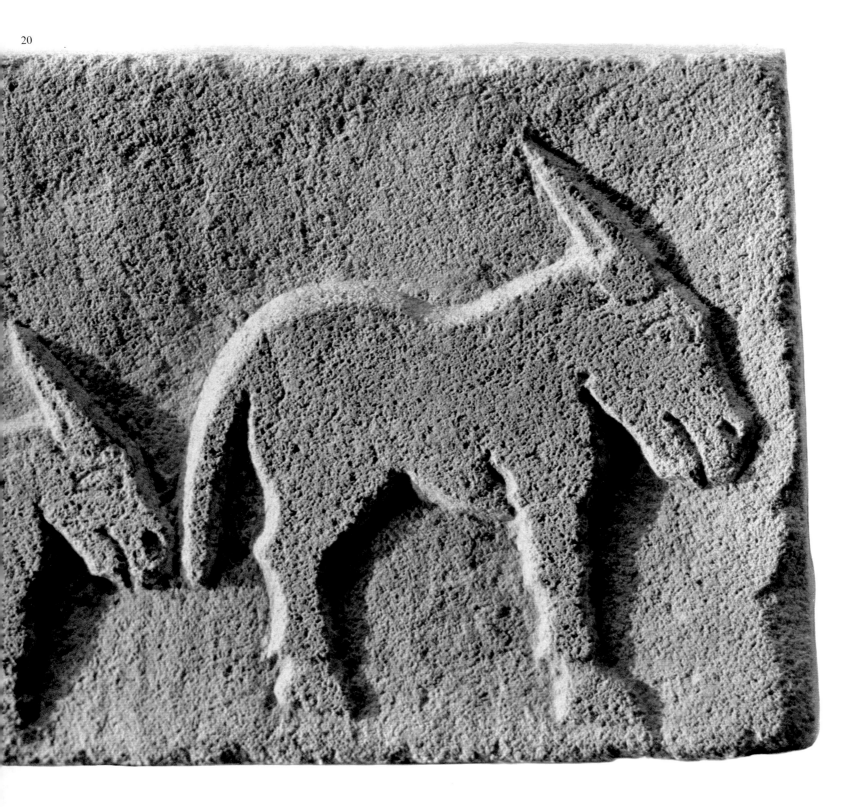

21. Horses. Relief in stone from the sanctuary of El Cigarralejo de Mula, Murcia.
 Emeterio Cuadrado Collection, Madrid.

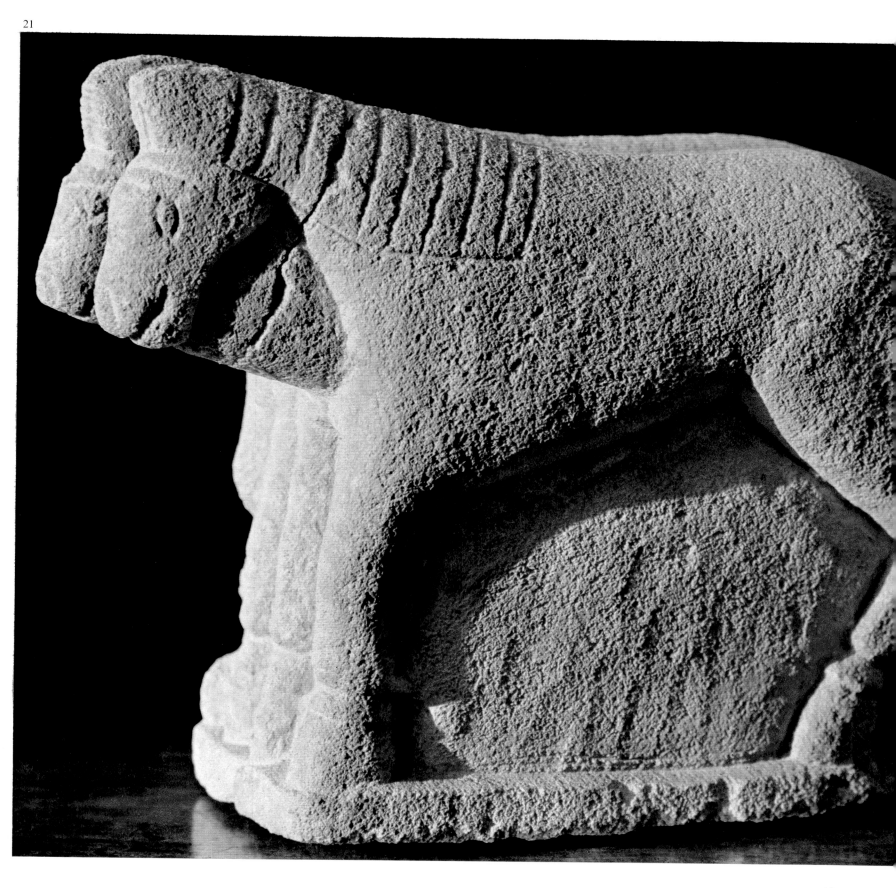

22

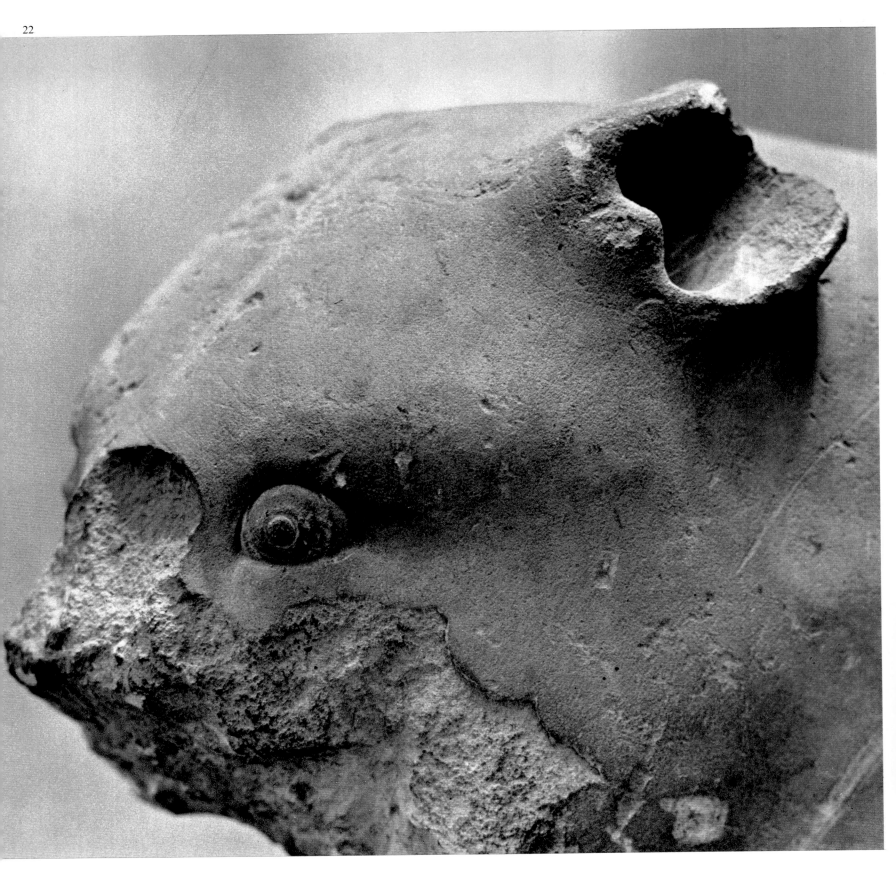

23. Stone lion, from Castro del Río, Cordova.
Archaeological Museum of Cordova.

23

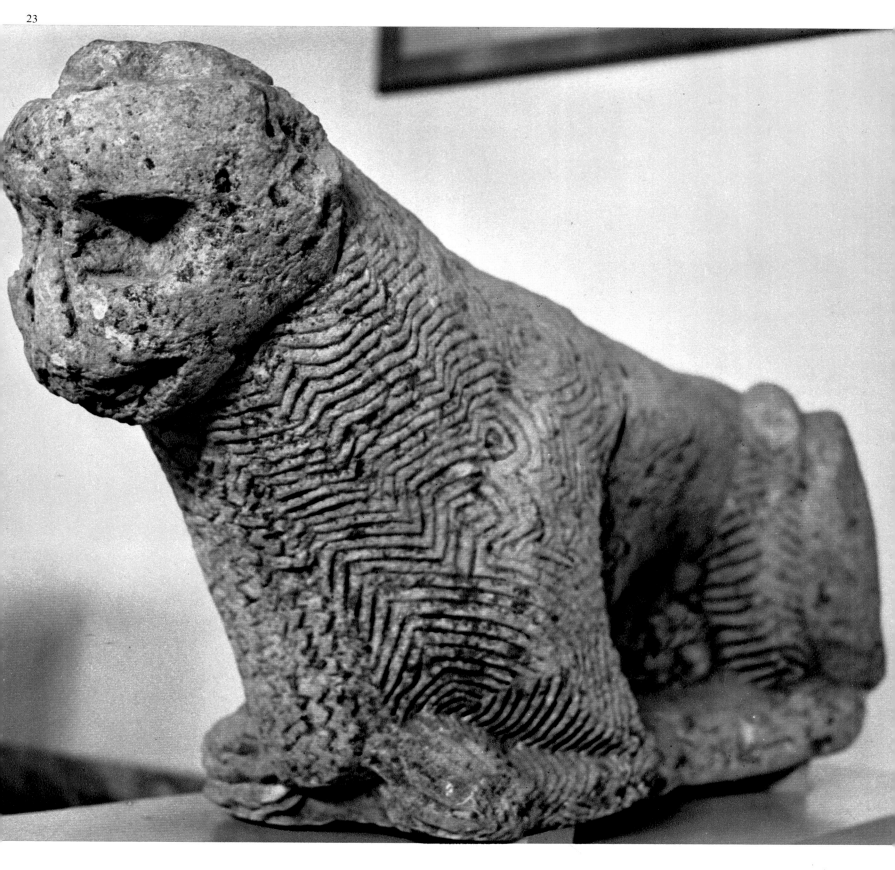

24. Detail of the lion's head from Nueva Carteya. Archaeological Museum of Cordova.
(the whole figure can be found on page 40).

24

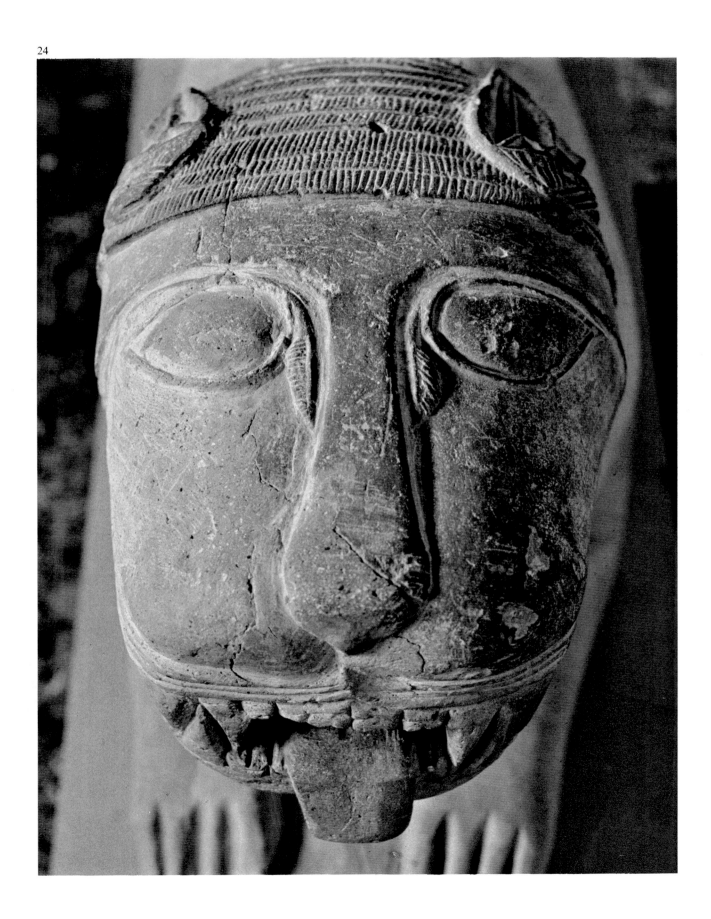

25

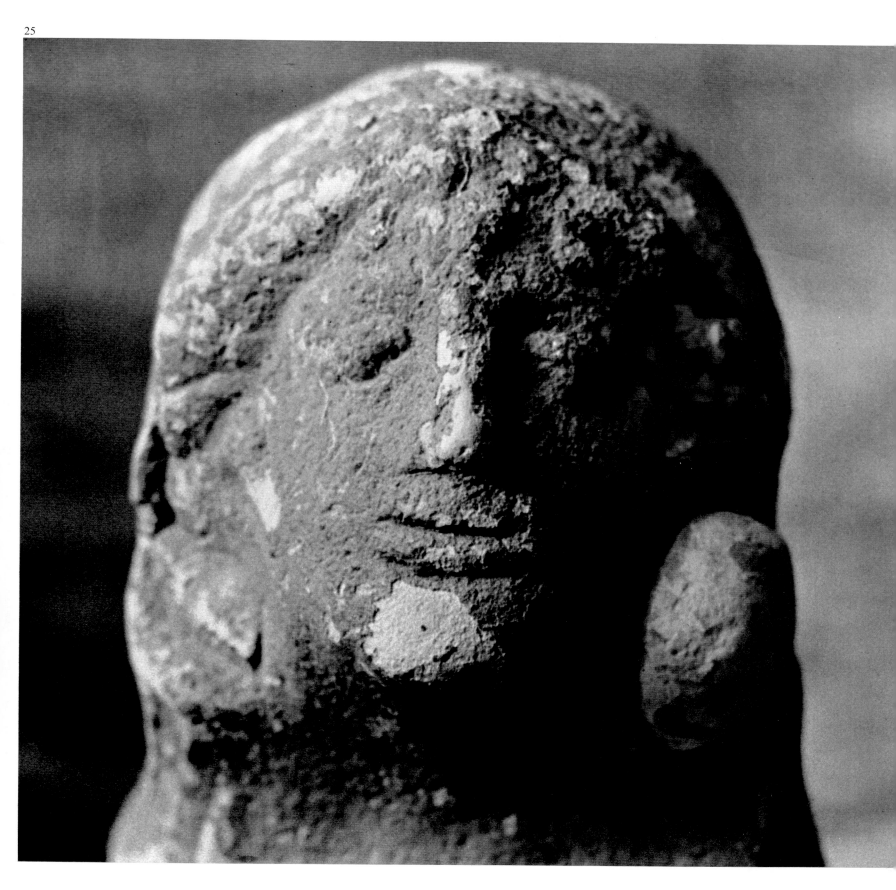

26. Horse. Relief in stone from the sanctuary of El Cigarralejo de Mula, Murcia.
 Emeterio Cuadrado Collection, Madrid.

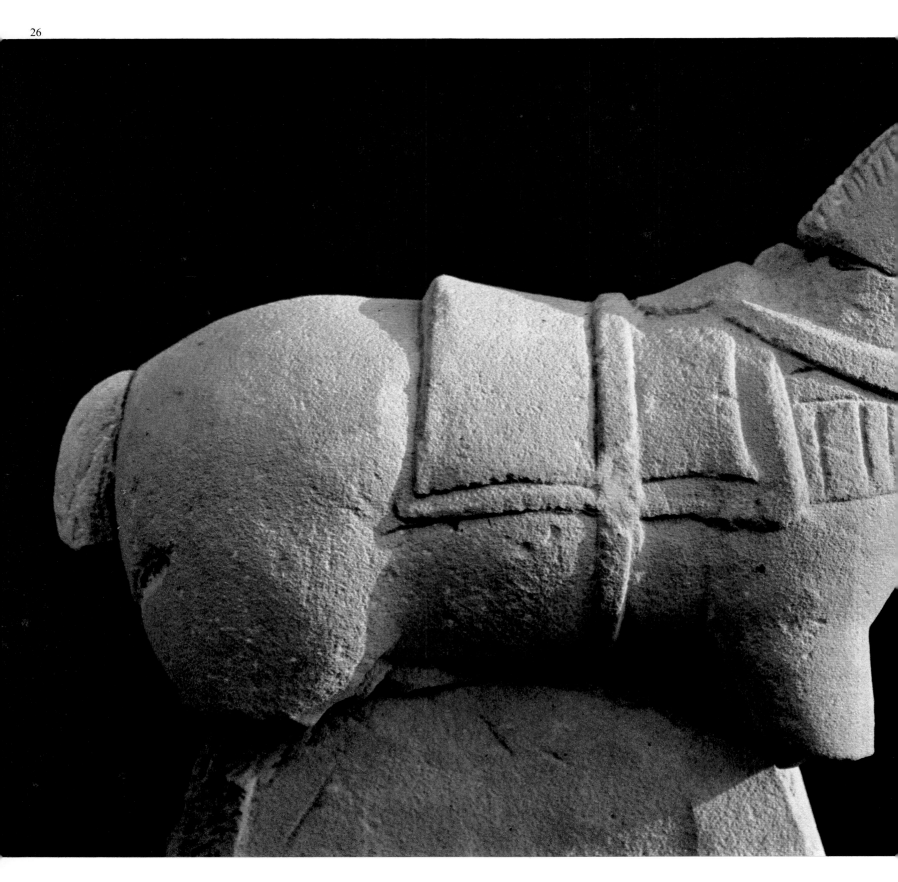

27

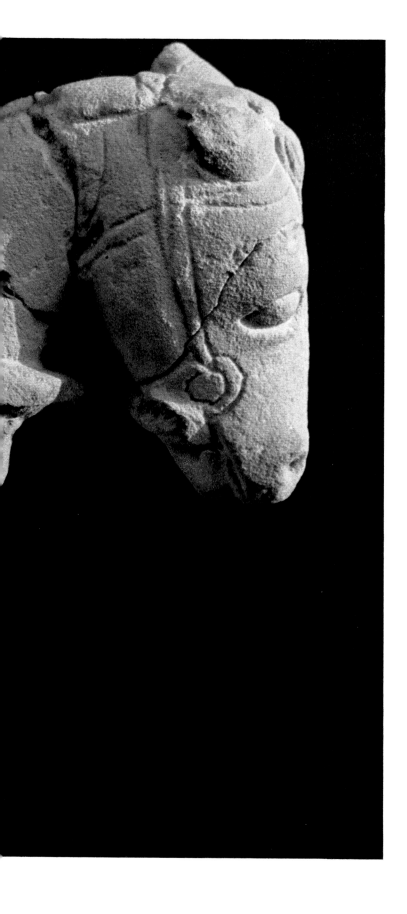

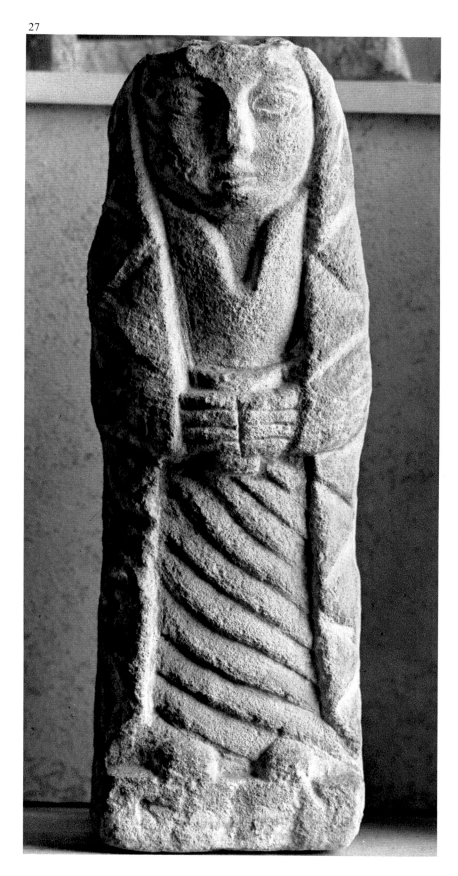

28, 29. Details of the so-called "Great Lady," an offering figure in stone from the Cerro de los Santos.
National Archaeological Museum, Madrid. See also Fig. 78.

28

29

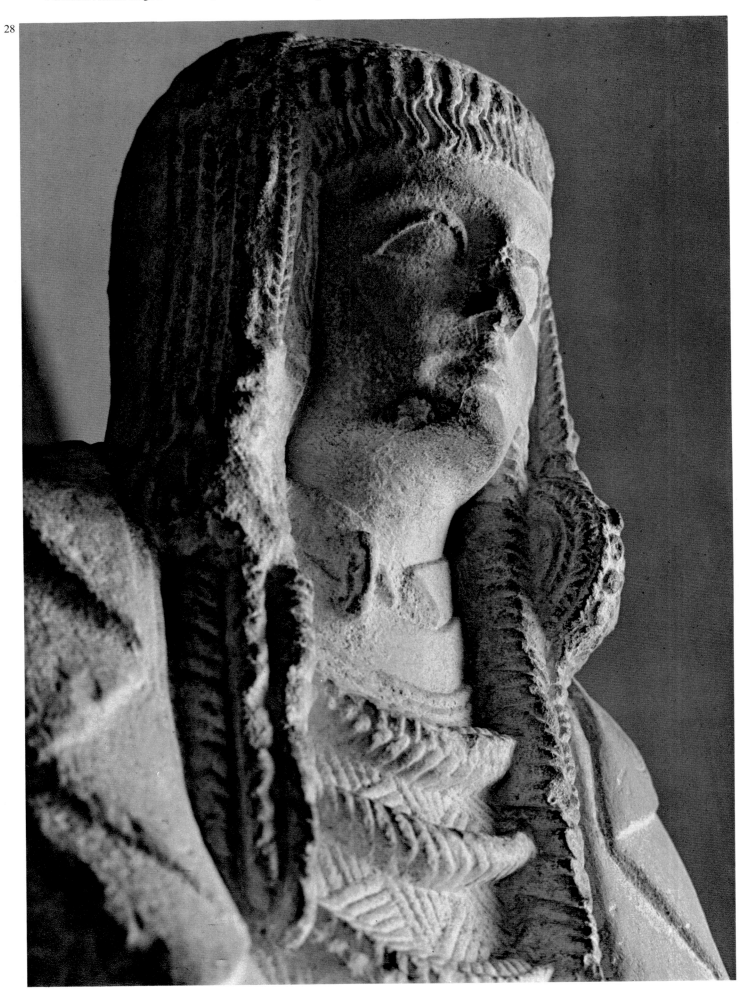

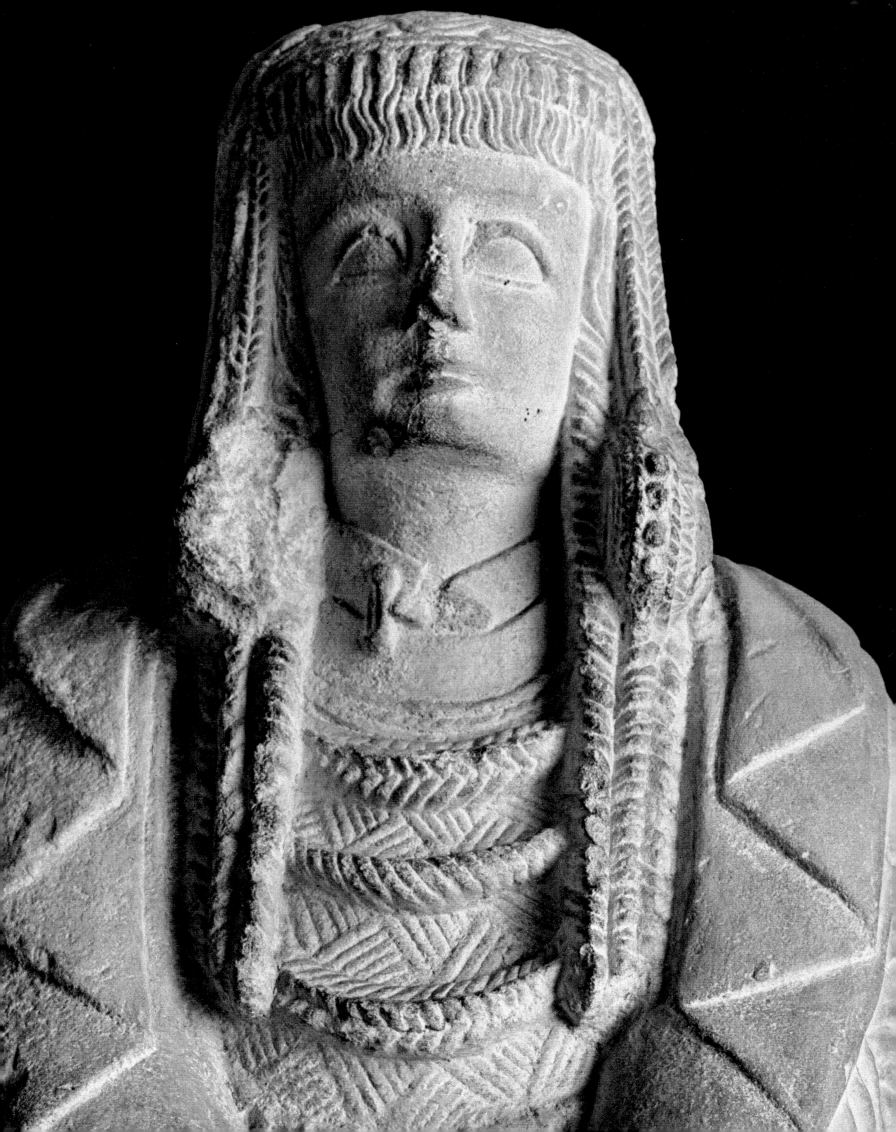

30

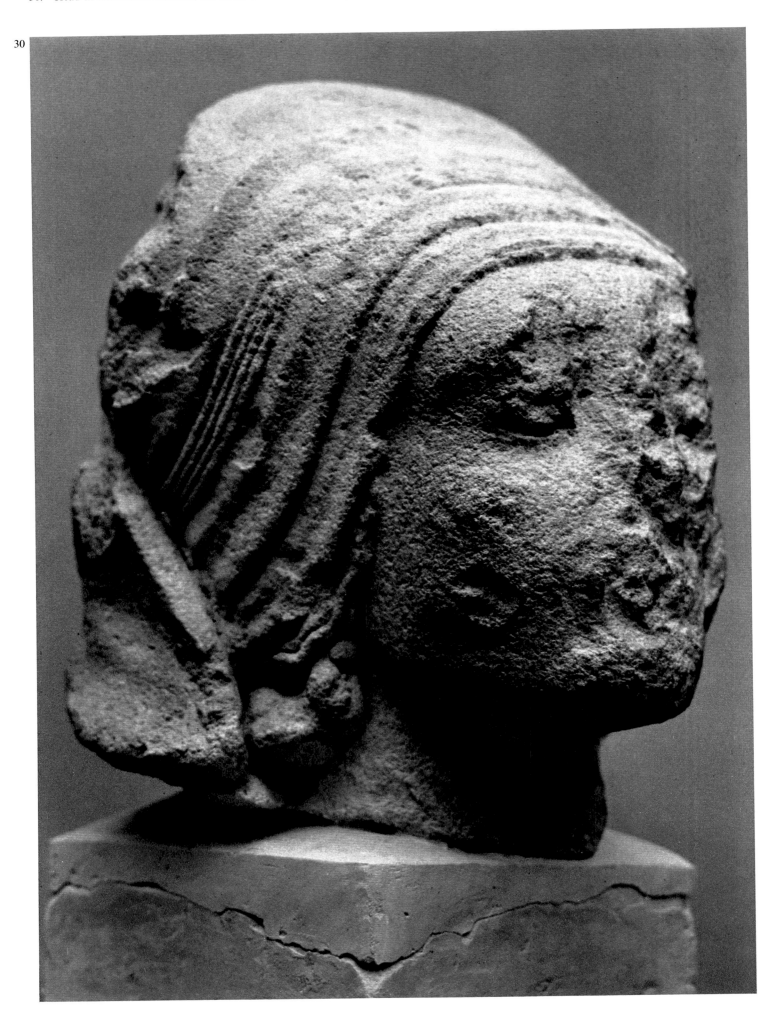

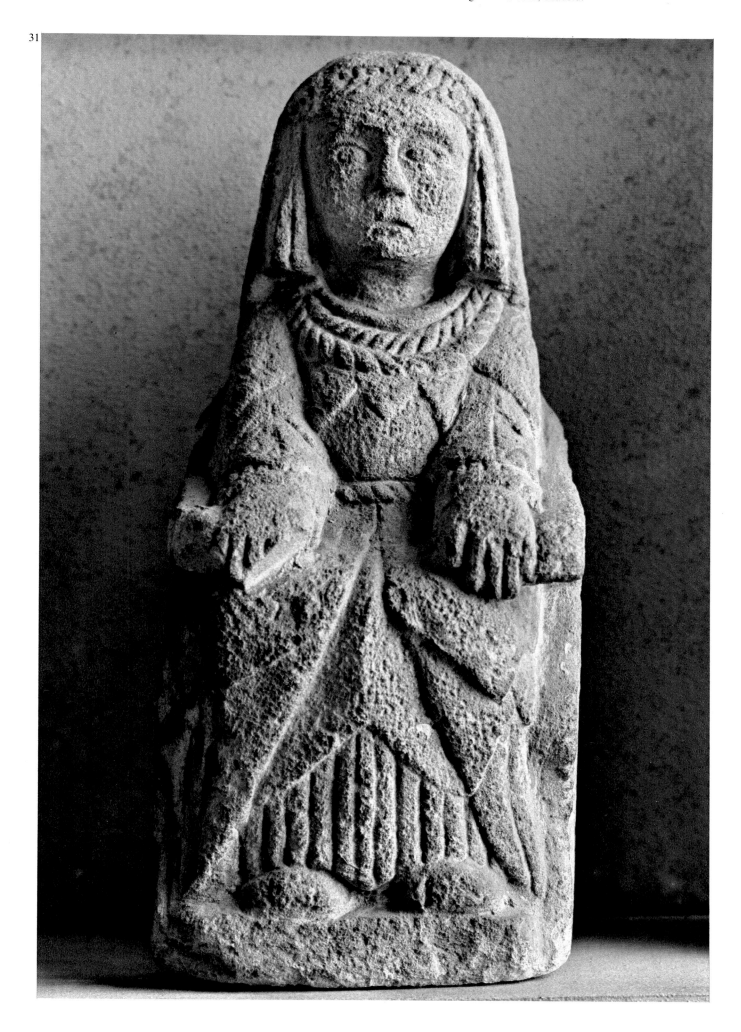

32

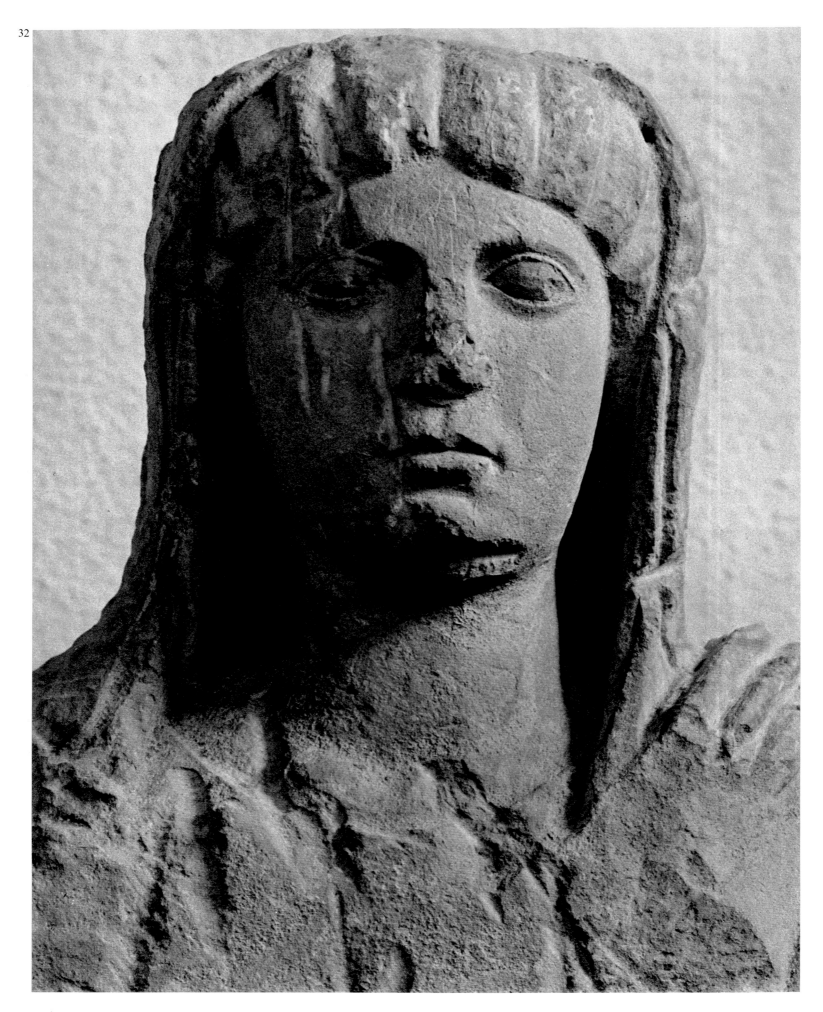

33. "The Lady of Baza." Limestone with very well preserved polychrome. Funerary statue from the collection of offerings in the tomb. 4th century. National Archaeological Museum, Madrid.

33

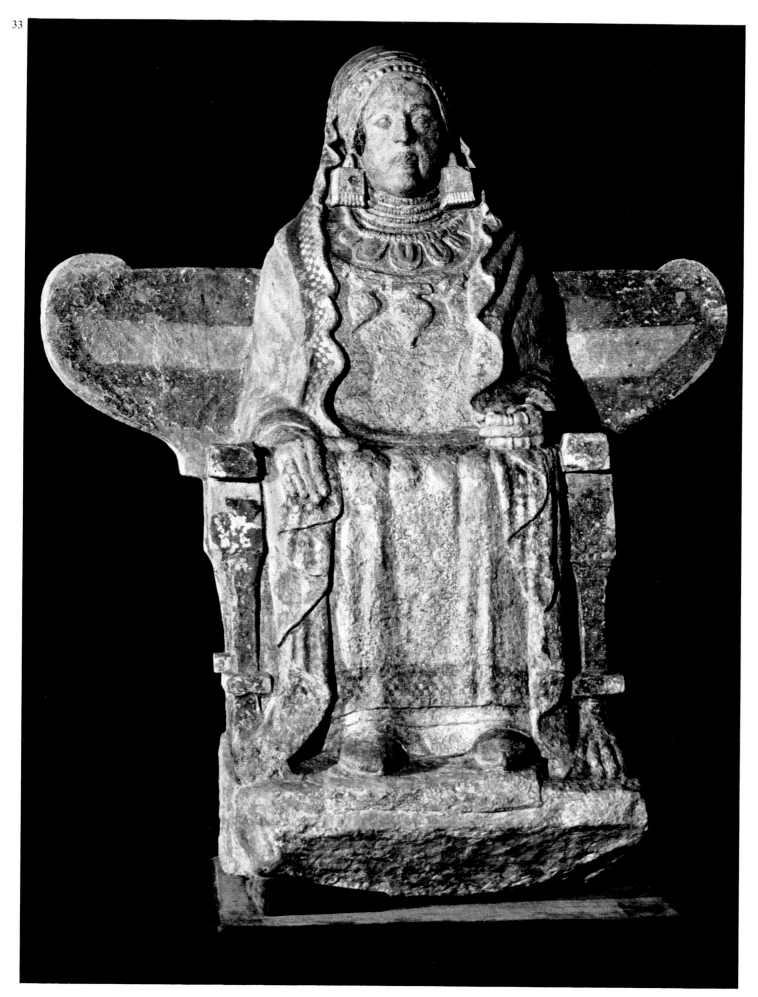

34. Offerer. Sculpture in stone. Cerro de los Santos. National Archaeological Museum. Madrid.

35. Bronze figurine, greatly enlarged, forming part of a pair of oxen ploughing. Settlement of La Bastida de Mogente, Valencia. Prehistory Museum of Valencia.

34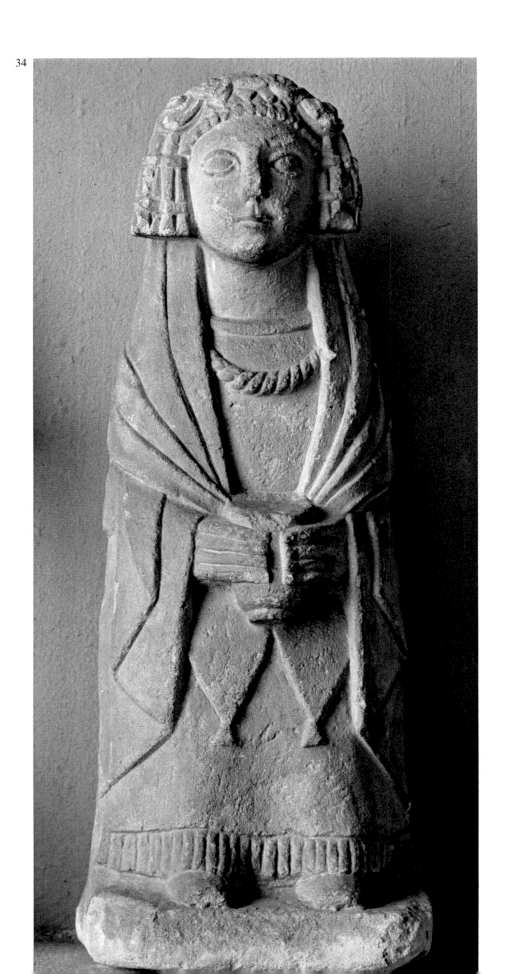

35

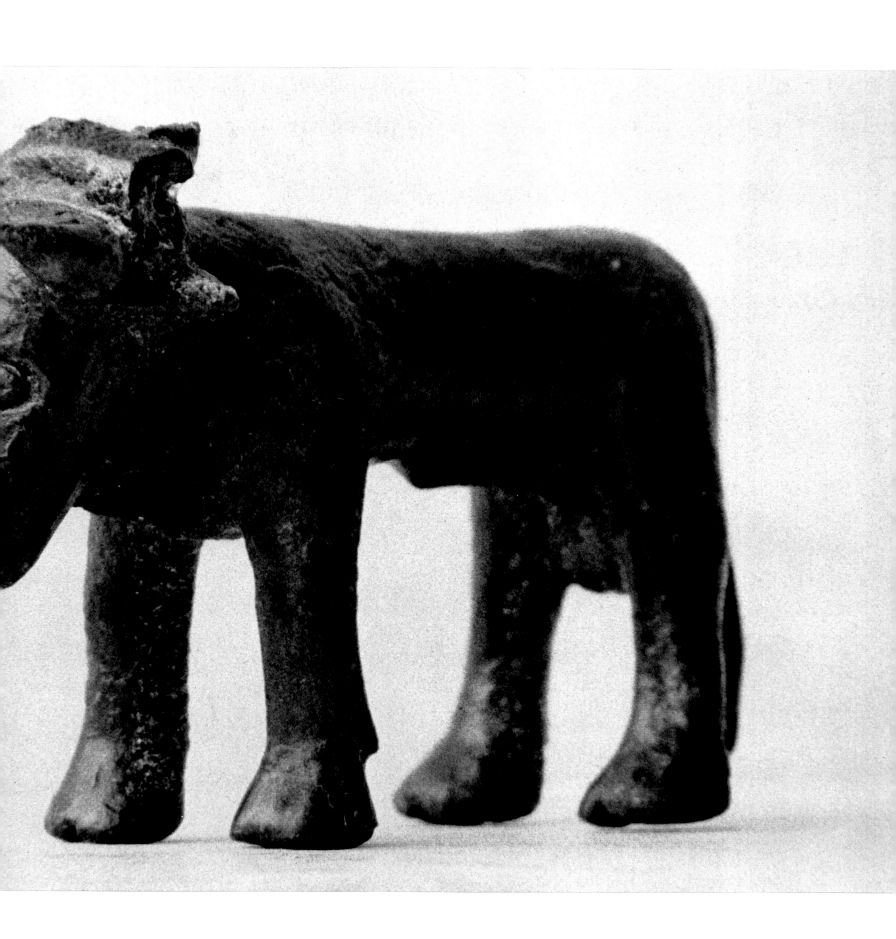

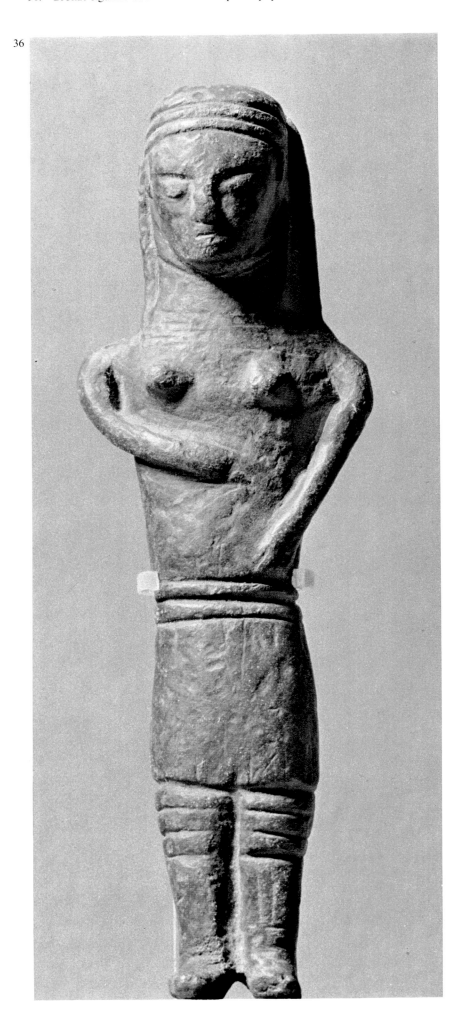

36

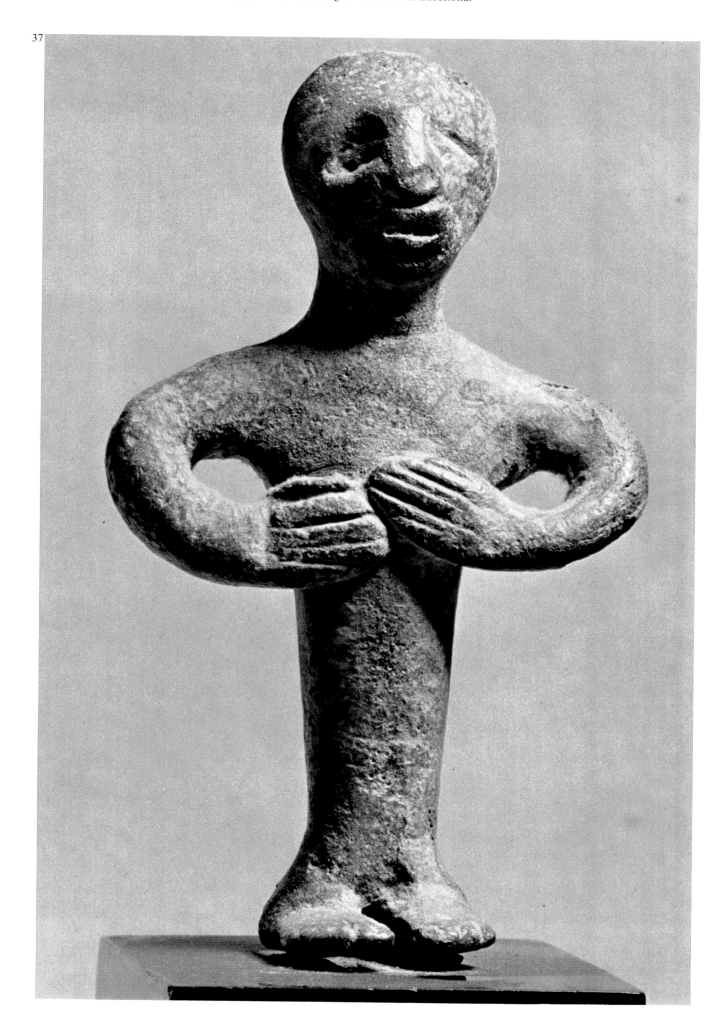

38. Warrior on horseback. Small bronze from the settlement of La Bastida de Mogente, Valencia. (Enlarged. Height of the original: 6.5 cm) 4th century B.C. Prehistory Museum of Valencia.

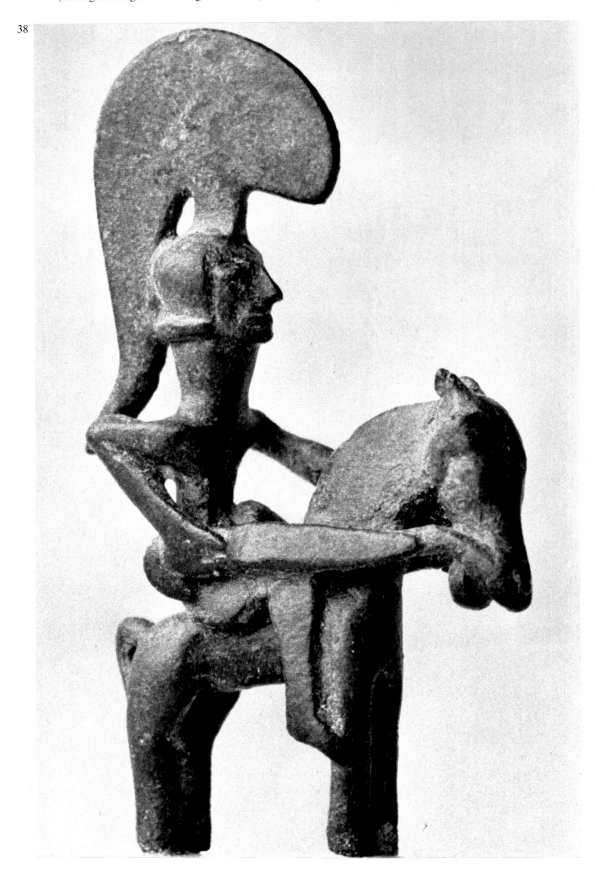

39. Rider. Bronze figurine from the sanctuary of La Luz, Murcia. Archaeological Museum of Barcelona.

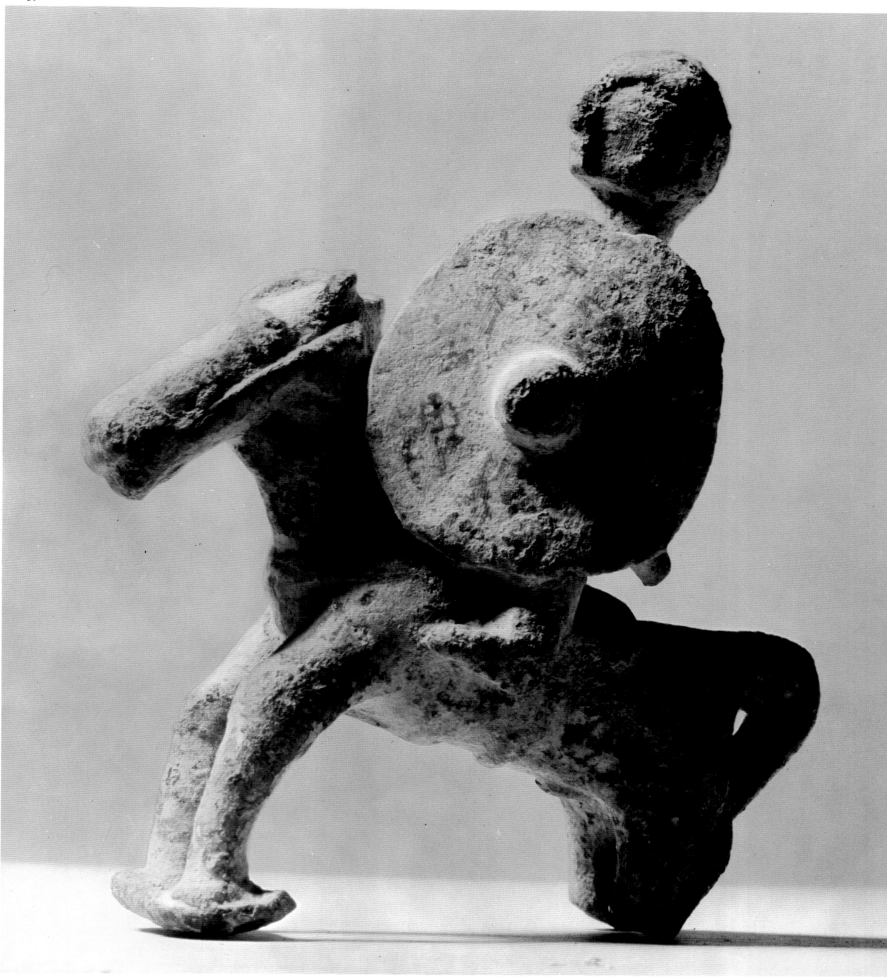

40. Bronze figurine from the sanctuary of Castillar de Santisteban, Jaén. Archaeological Museum of Barcelona.

40

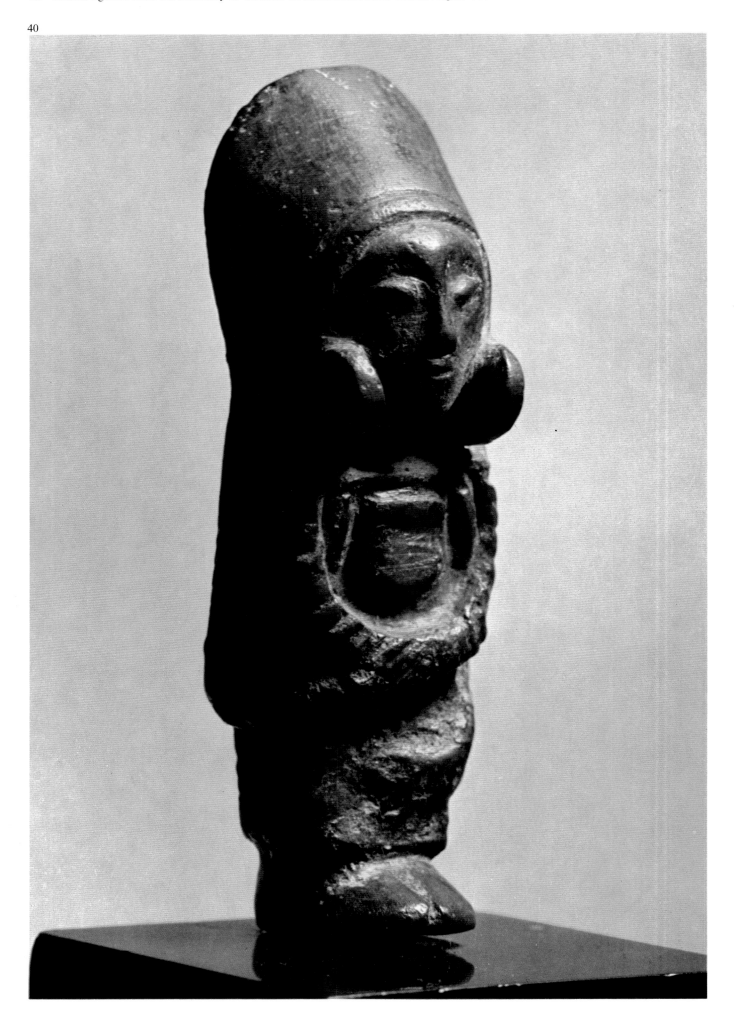

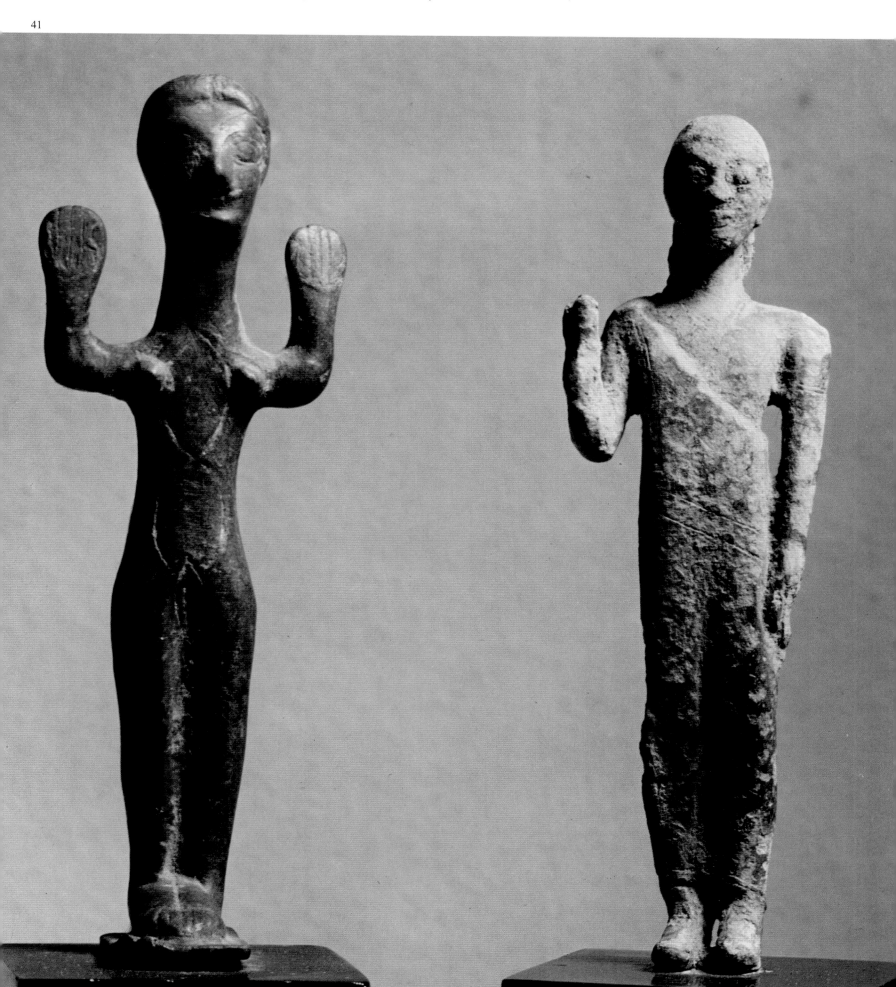

41. Devotees in attitude of adoration. Bronze figurines from the sanctuary of Castillar de Santisteban, Jaén.

41

42. Funerary stele, with the representation of a rider and a series of spearheads. From the district of Caspe. Archaeological Museum of Barcelona.

43. Detail of the vase "of the goats," from the necropolis of El Cabecico del Tesoro, Murcia. Archaeological Museum of Murcia.

42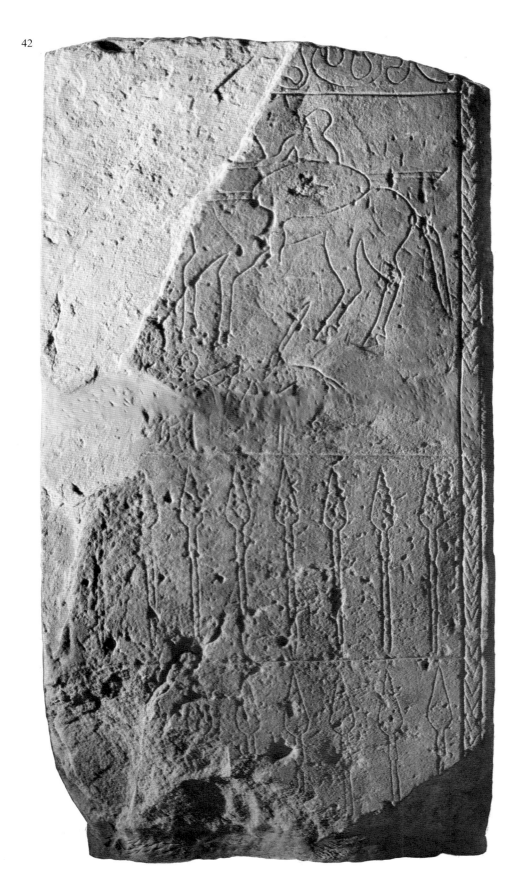

43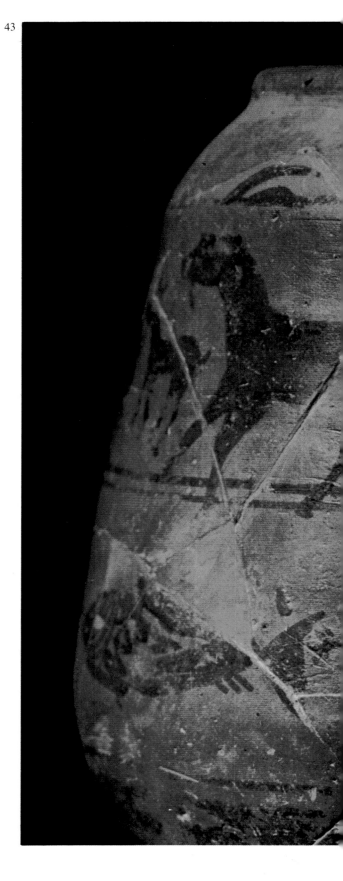

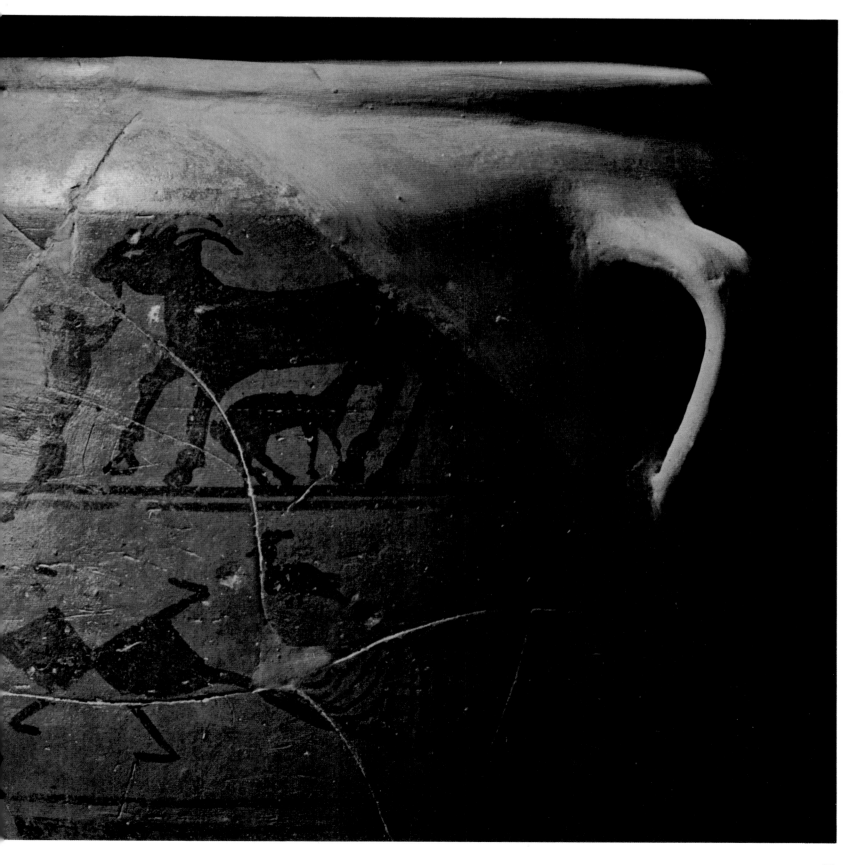

44. Warrior with spear. Small bronze found in Els Plans, near Villajoyosa, Alicante. Archaeological Museum of Alicante.

44

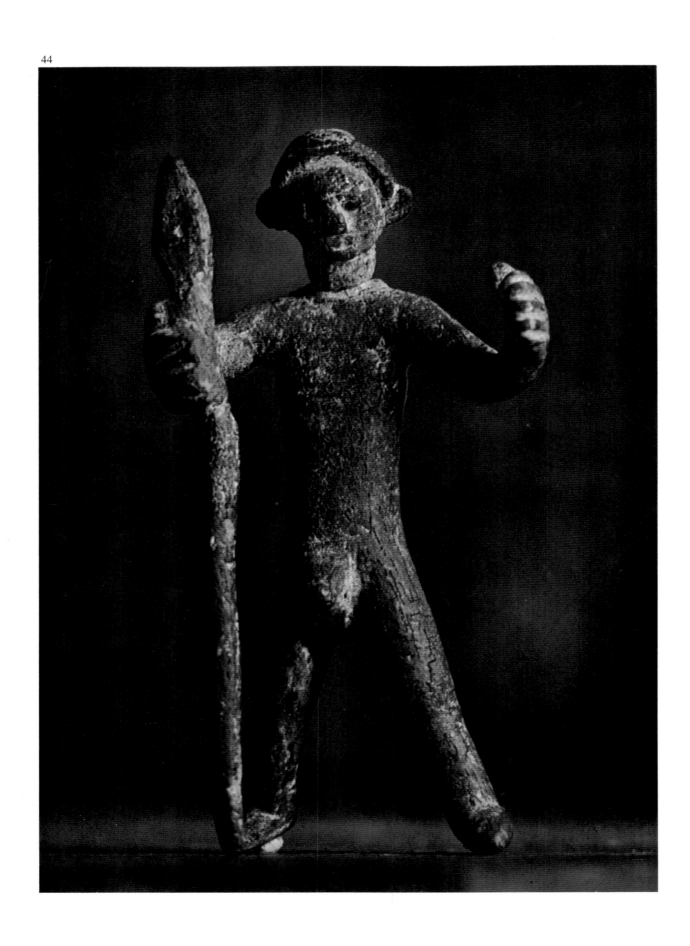

45. Two bronzes from the Iberian sanctuaries of Despeñaperros. Former Pérez Caballero Collection. Prehistory Museum of Valencia.

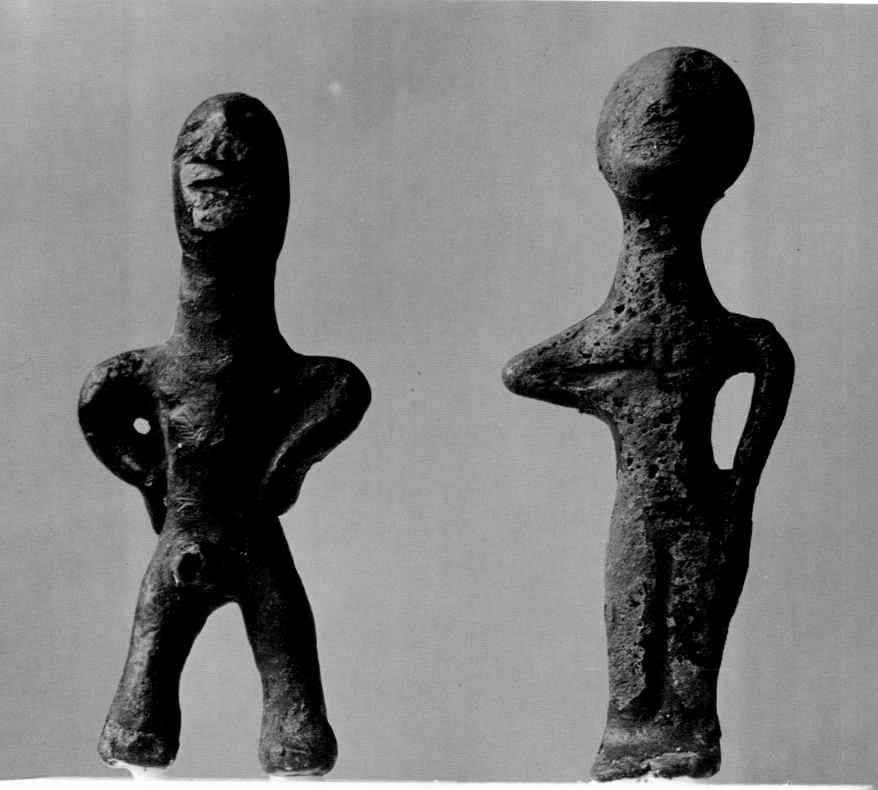

46. Two small bronzes from the sanctuaries of Despeñaperros.
 Prehistory Museum of Valencia.

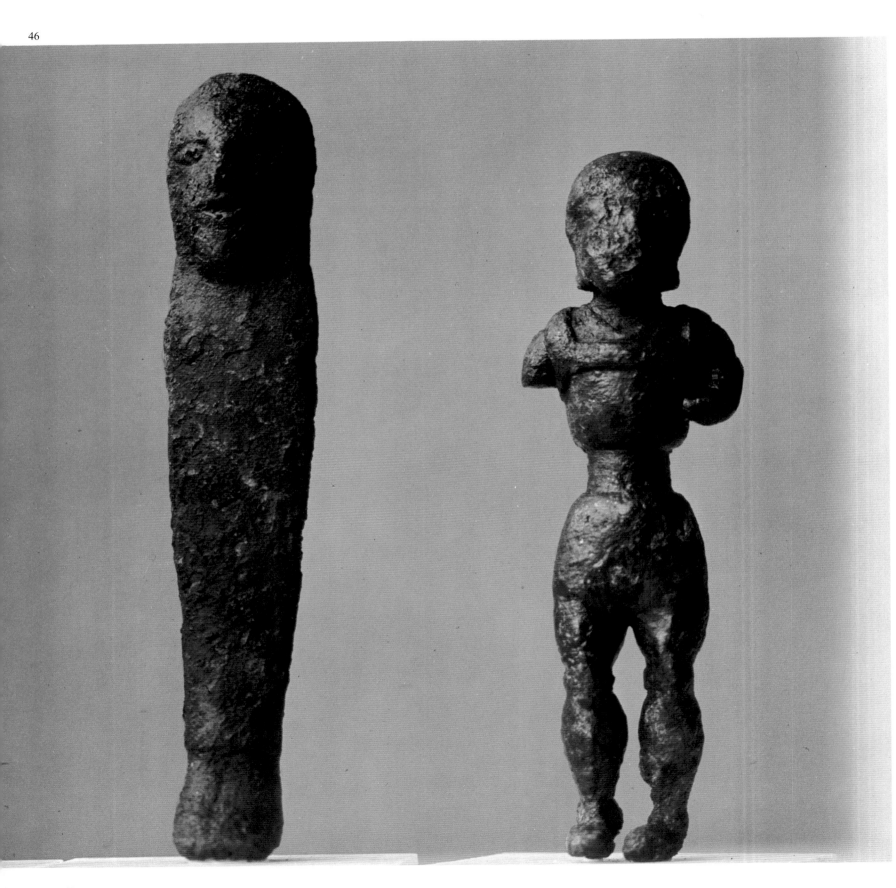

47. Offerer. Small bronze from the sanctuary of Castillar de Santisteban, Jaén.
 Archaeological Museum of Barcelona.

47

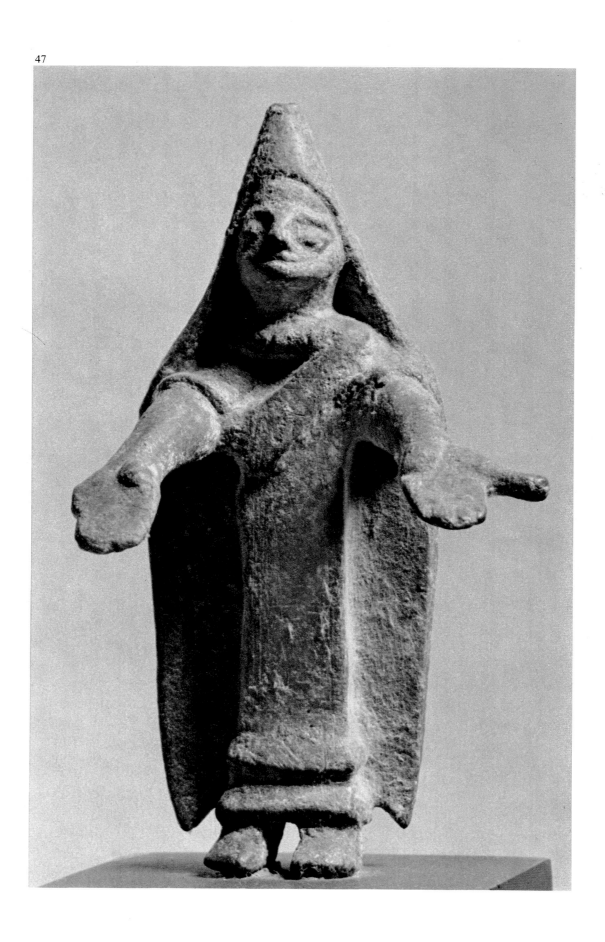

48. Piece of metalwork from the treasure of Tivisa, Tarragona.

48

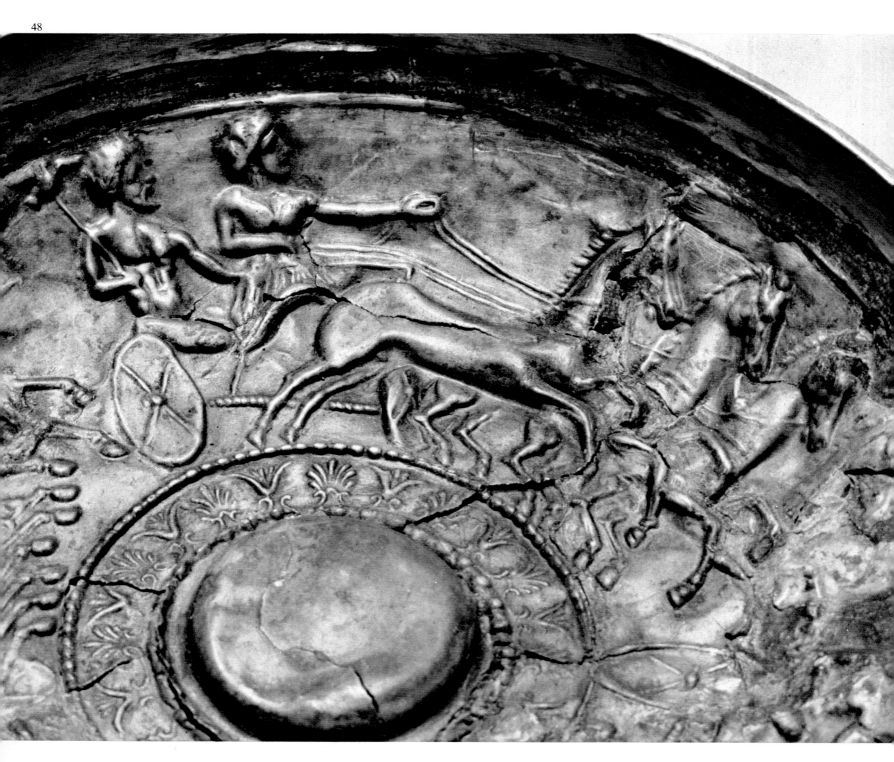

49. Vase from the settlement of San Miguel de Liria, Valencia. (Height 25 cm.) 2nd-Ist centuries B.C. Prehistory Museum of Valencia.

49

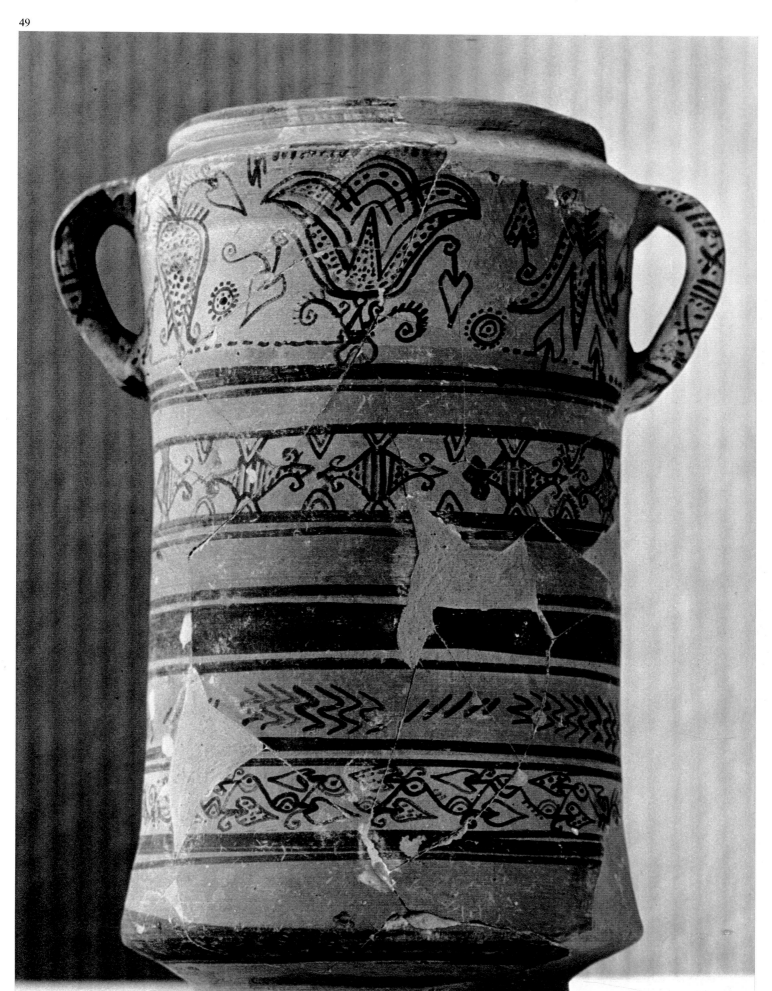

50. Detail of the painting of a vessel from the settlement of San Miguel de Liria. Valencia. 2nd-1st centuries B.C. Prehistory Museum of Valencia.

50

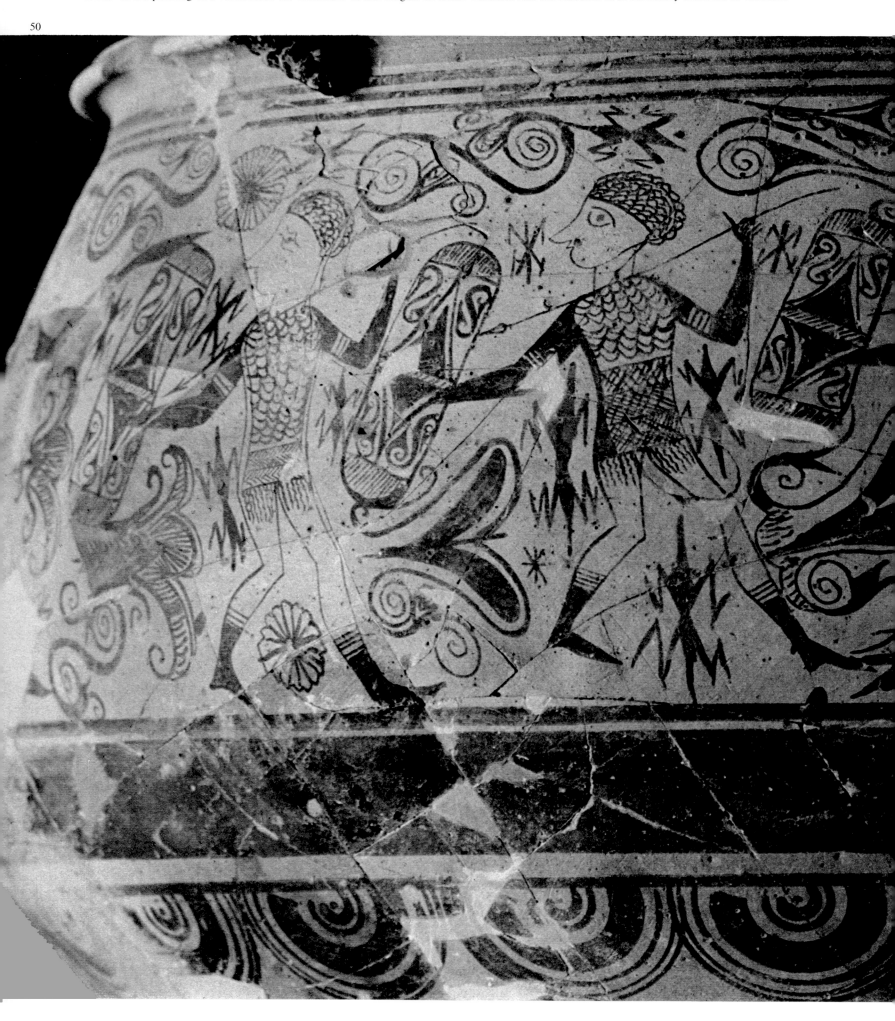

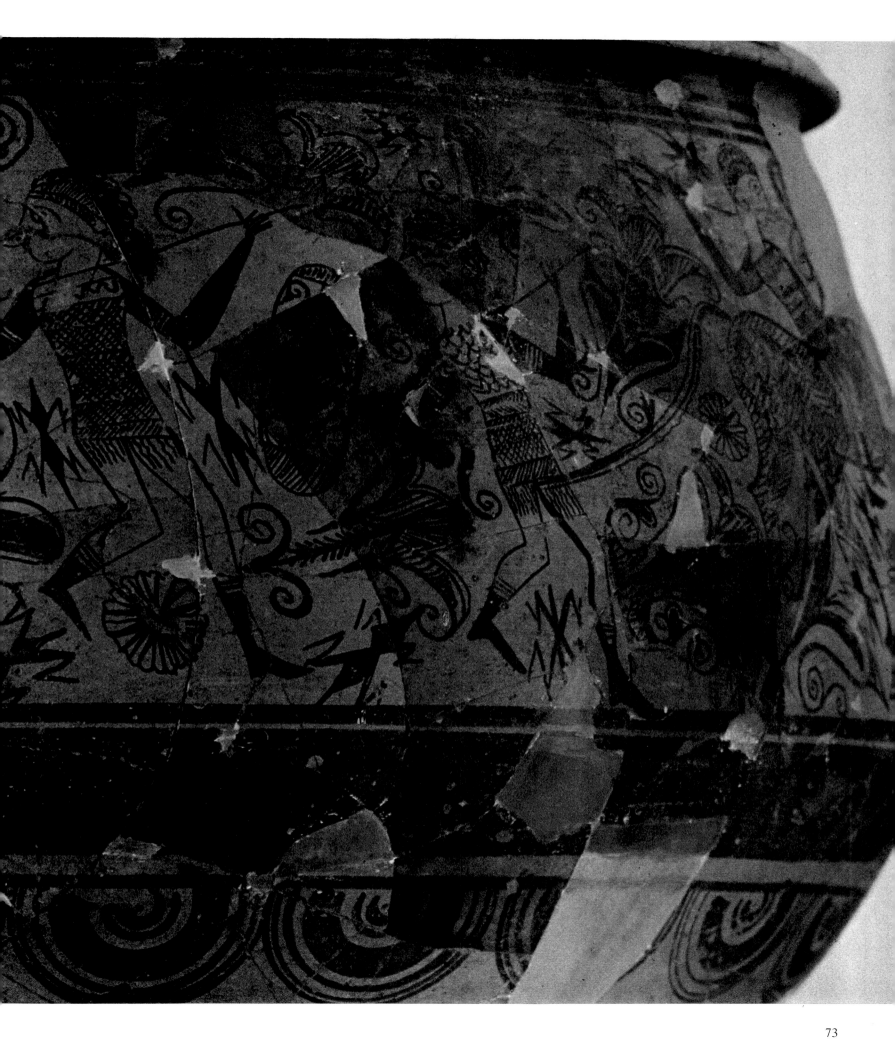

51, 52. Painted jars from the settlement of El Tossal de les Tenalles, Sidemunt, Province of Lérida. 2nd century B.C.
Archaeological Museum of Barcelona.

53. Painted vessel of the last period of Iberian ceramics, about the beginning of the Christian era, from El Tossal de Manises, Alicante.
Archaeological Museum of Alicante.

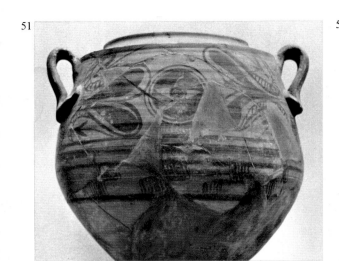

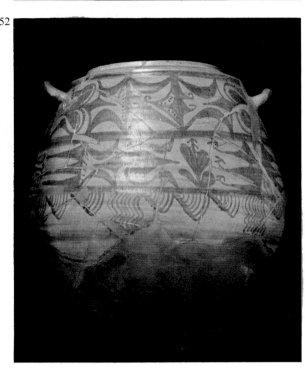

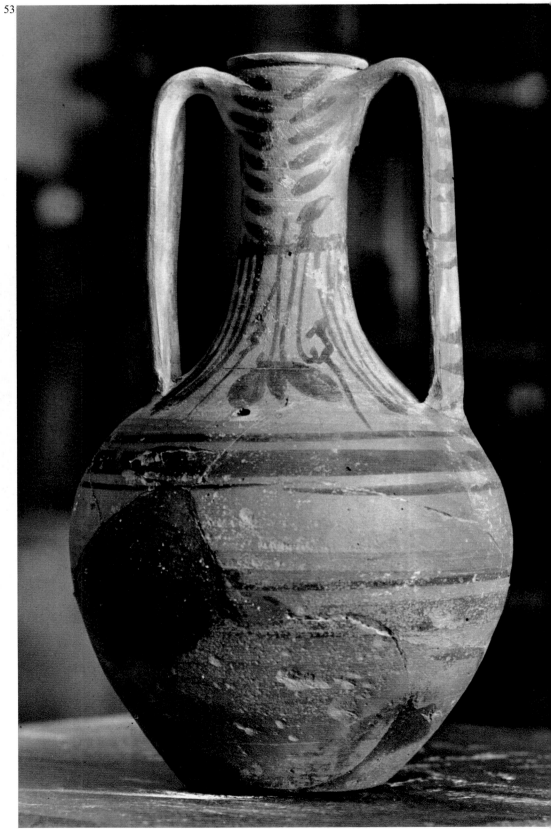

54. Fragment of painted pottery from El Tossal de les Tenalles, Sidemunt, Province of Lérida. 2nd century B.C.

55. Vase from the settlement of San Miguel de Liria, Valencia, with painted Iberian inscription on the upper part. 2nd-Ist centuries B.C.
Prehistory Museum of Valencia.

56. Painted vessel (symbolic style) from Archena, Murcia. 3rd-1st centuries B.C.
National Archaeological Museum, Madrid.

54
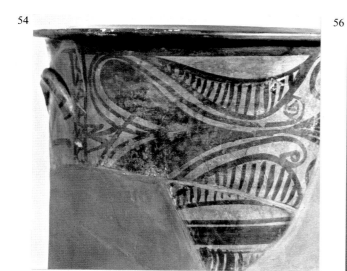

55
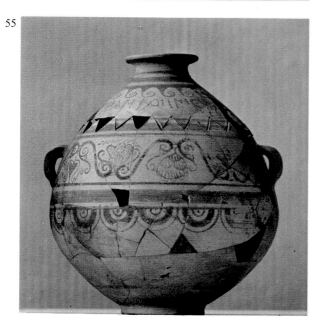

56
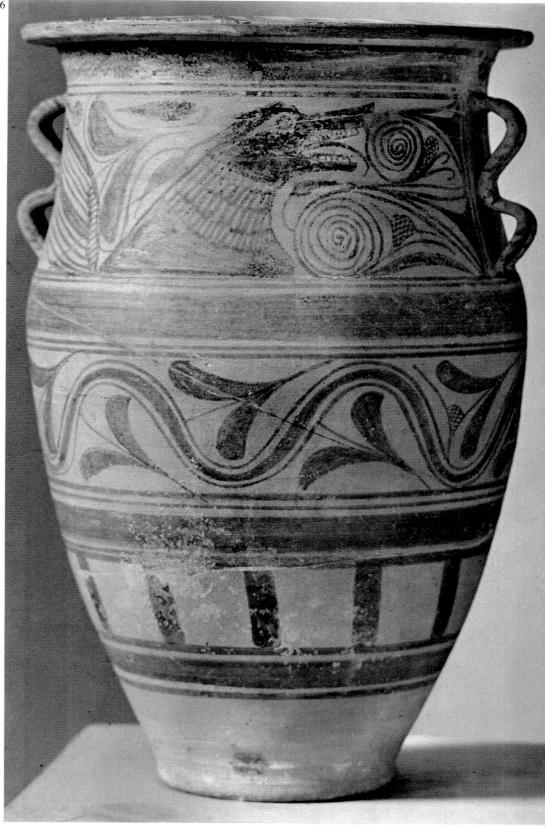

57

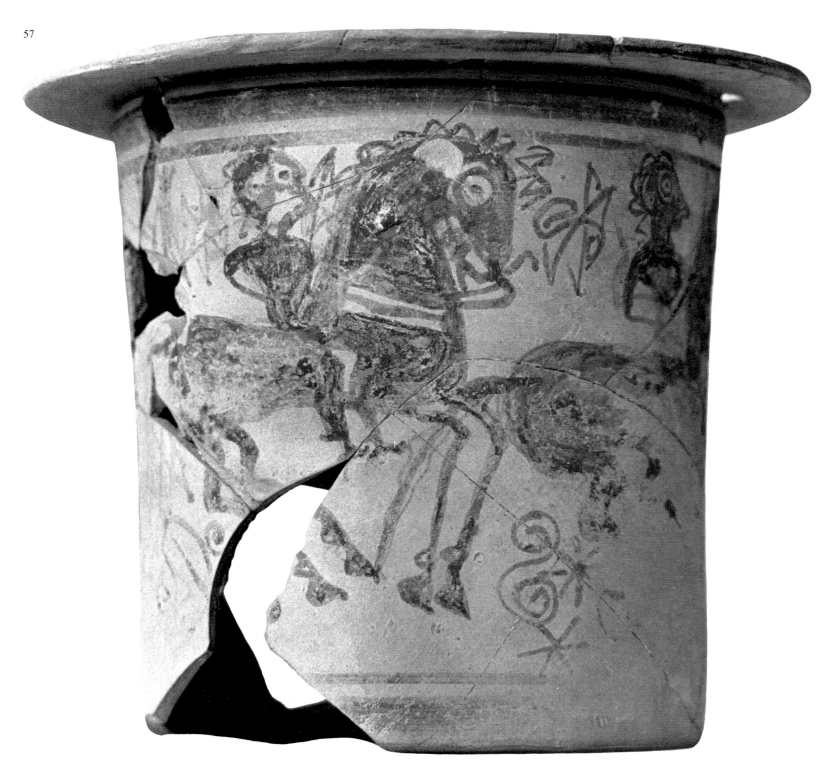

58 Detail of a painted vase, from El Tossal de Manises, Alicante. Archaeological Museum of Alicante.

58

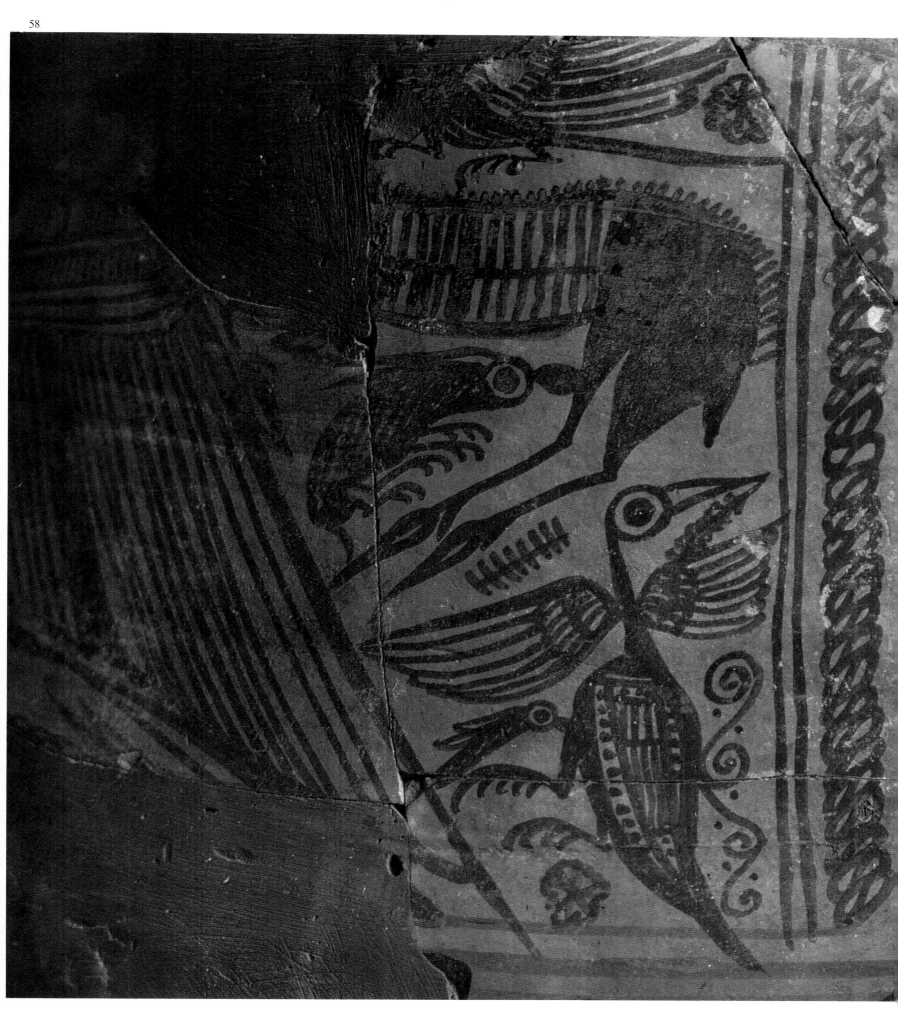

59. Detail of a painted vase from La Alcudia de Elche. Ramos Folques Collection, Elche.

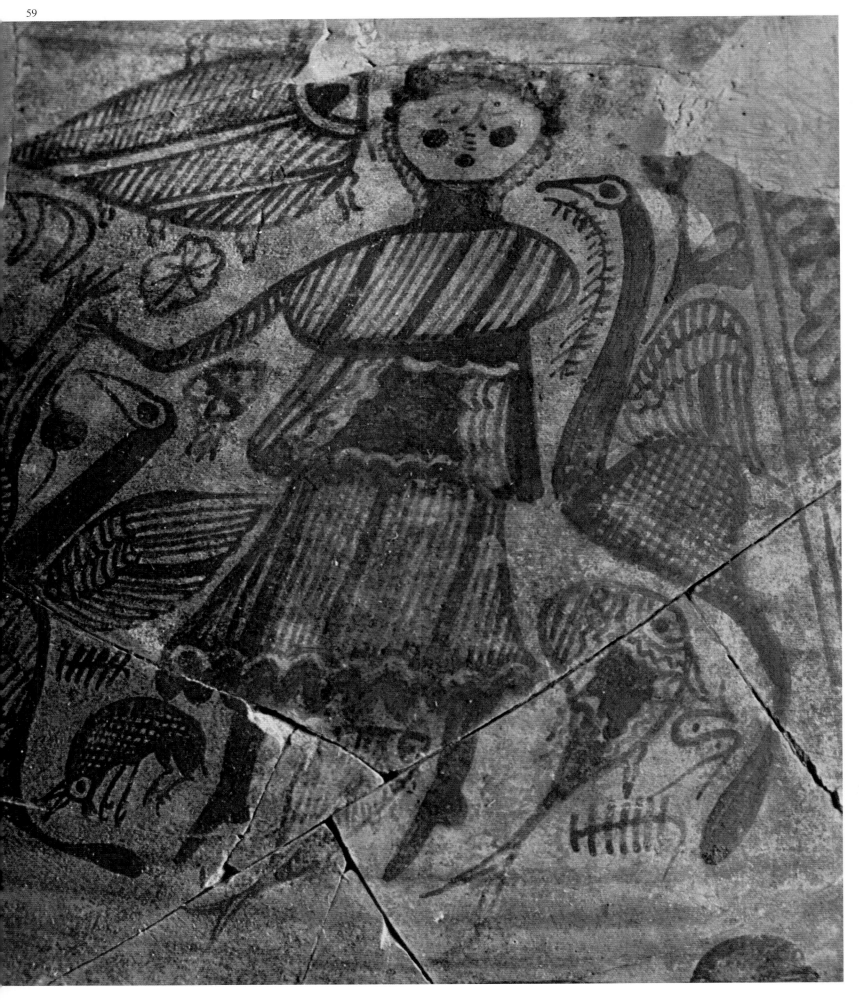

60. Detail of a painted vase from the necropolis of Oliva, Valencia. 2nd-1st centuries B.C. Prehistory Museum of Valencia.

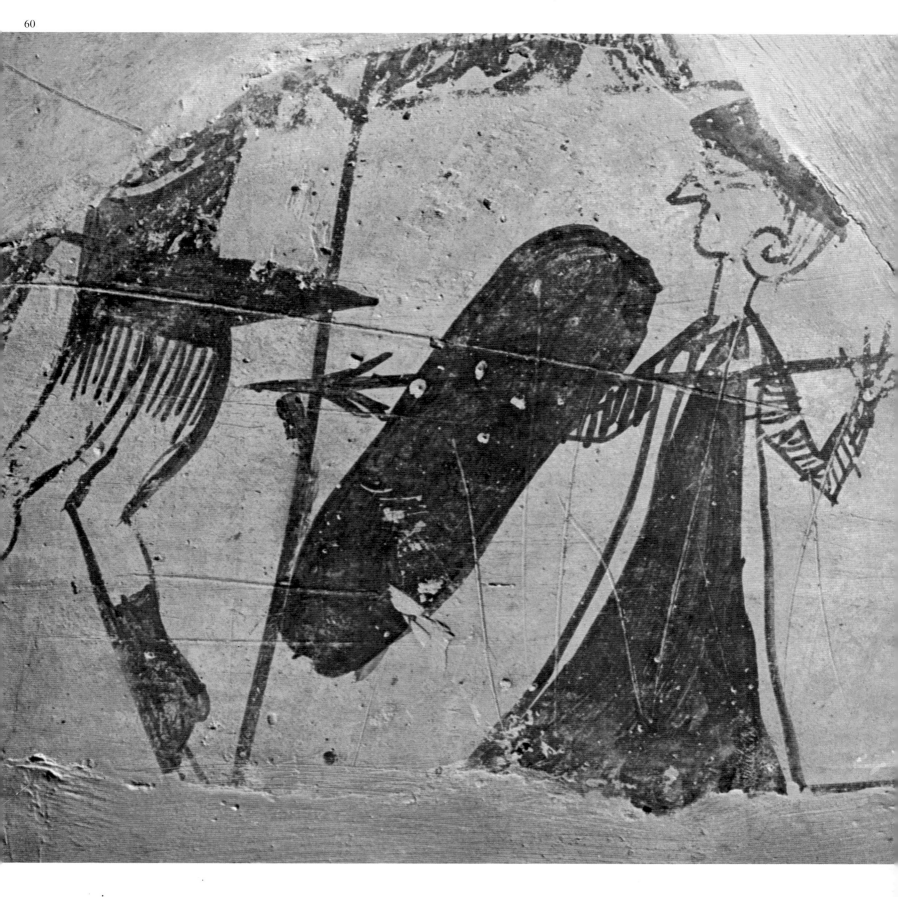

61. Warriors. Detail of a vase from the settlement of San Miguel de Liria, Valencia. 2nd-1st centuries B.C. Prehistory Museum of Valencia.

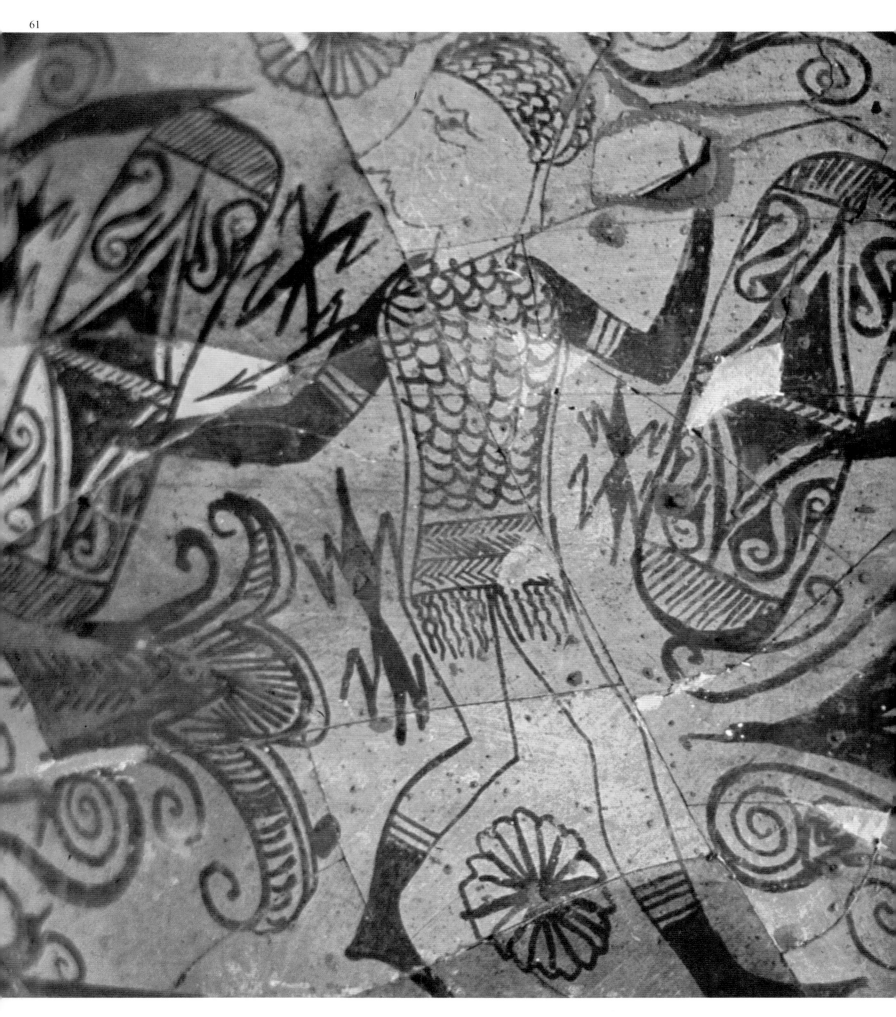

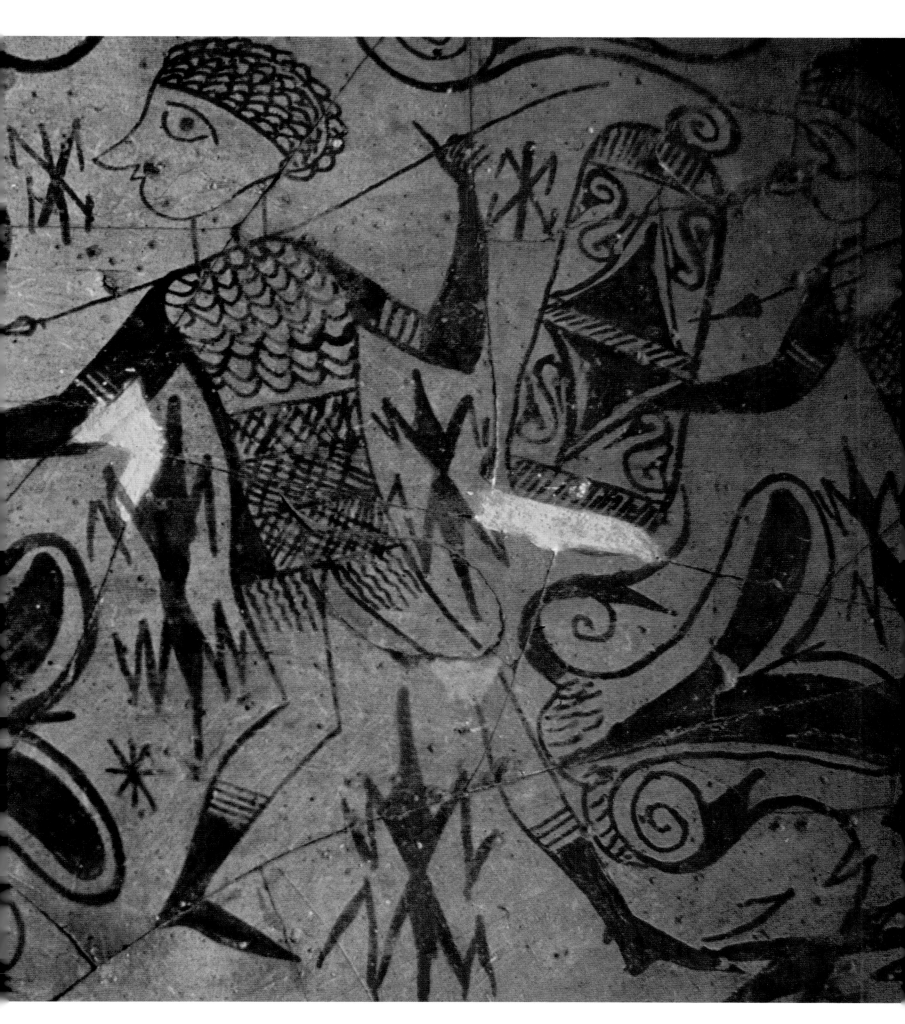

62. Warriors. Detail of the painting of a vase from the necropolis of Oliva, Valencia. 2nd-1st centuries B.C.
 Archaeological Museum of Barcelona.

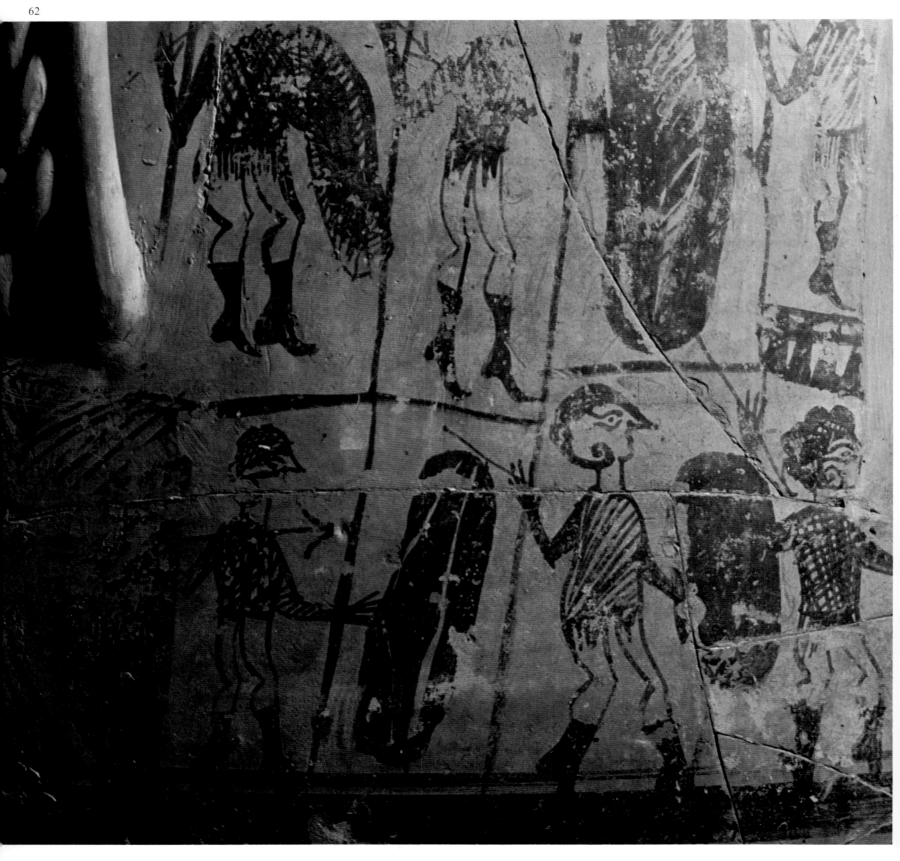

63. Detail of a painted vase —Elche-Archena style— from the settlement of El Tossal de la Cala, Benidorm, Alicante. Archaeological Museum of Alicante.

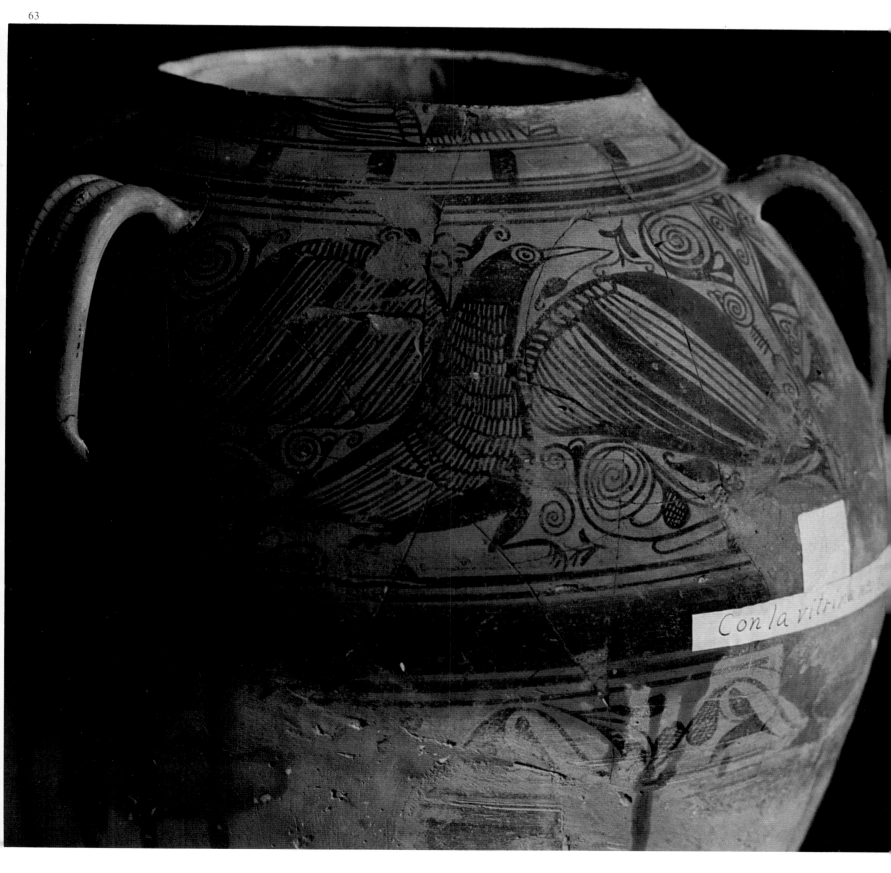

64. Obverse of an Iberian coin, 2nd-1st centuries B.C.
Numismatic Collection of Catalonia, Barcelona.

65. Obverse and reverse of a coin from Undikesken, Ampurias, —on the left— and two obverses of other Iberian coins, showing the type of masculine figure, probably of the divinity, typical of this series, 2nd-1st centuries B.C.

66. Obverse of a coin from the mint of Beligión, Aragón, 2nd-1st centuries B.C.

64

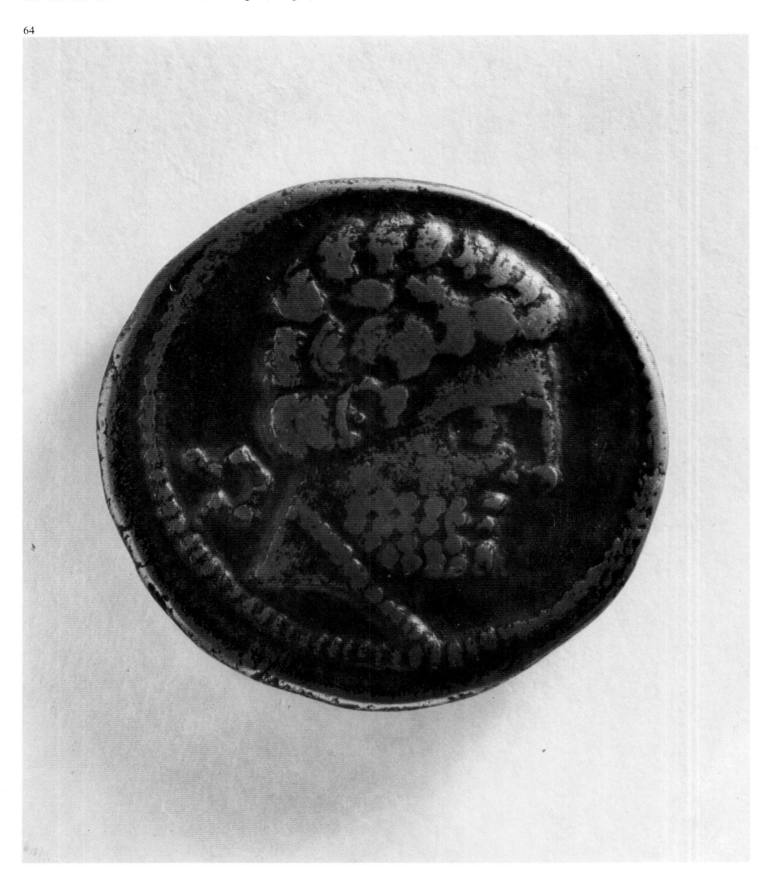

65

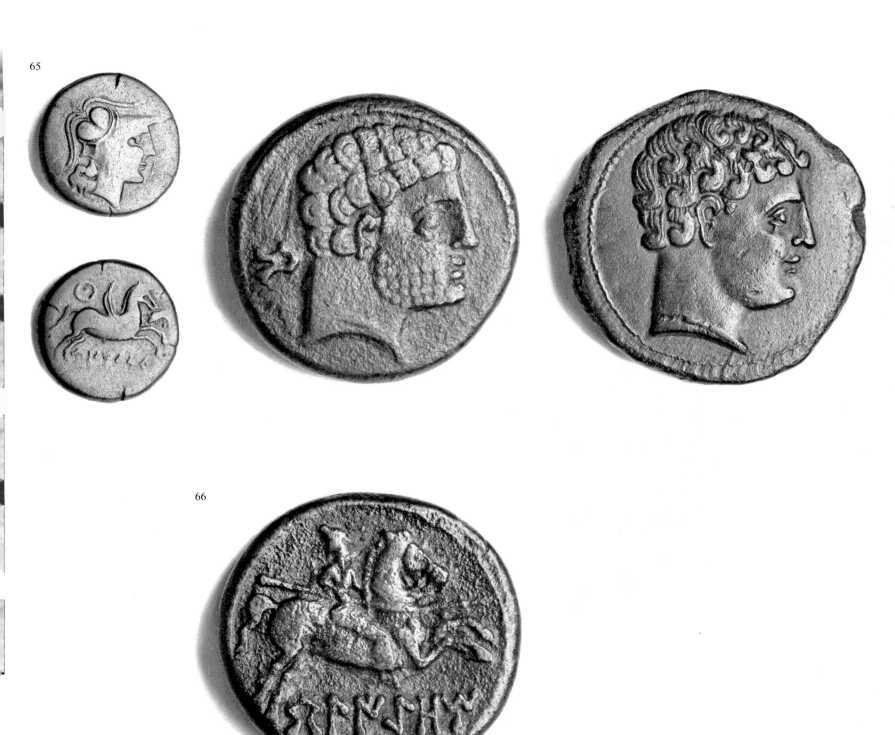

66

67. Painted *kalathos* or "top hat," from the necropolis of La Albufereta, Alicante. Archaeological Museum of Alicante.

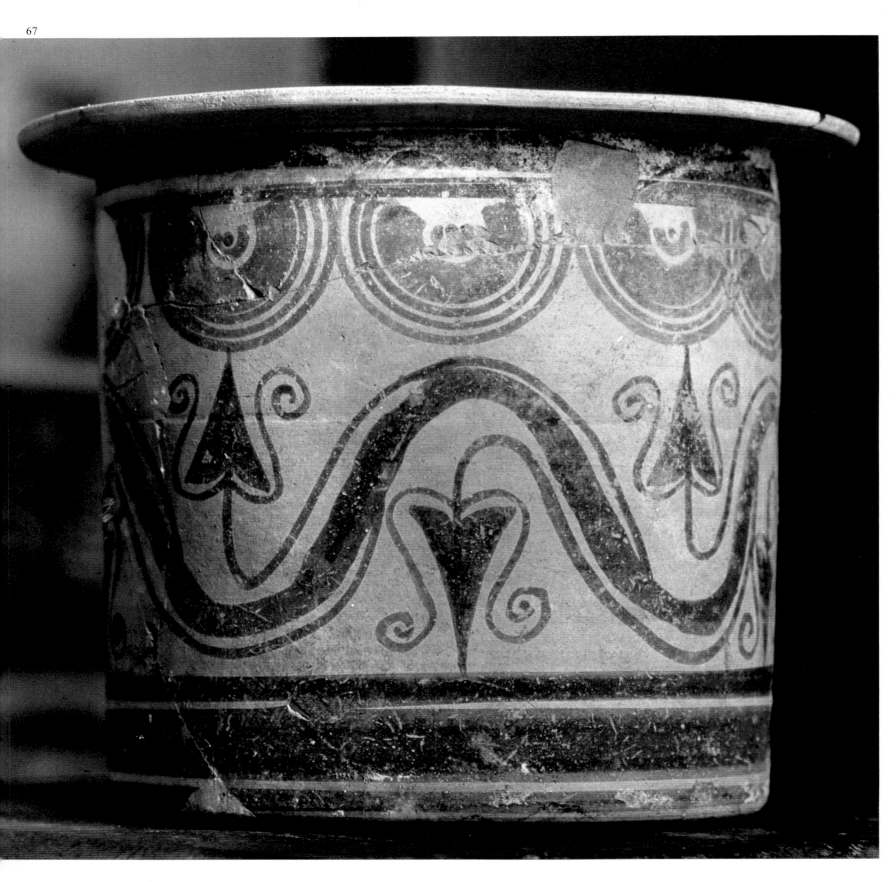

68

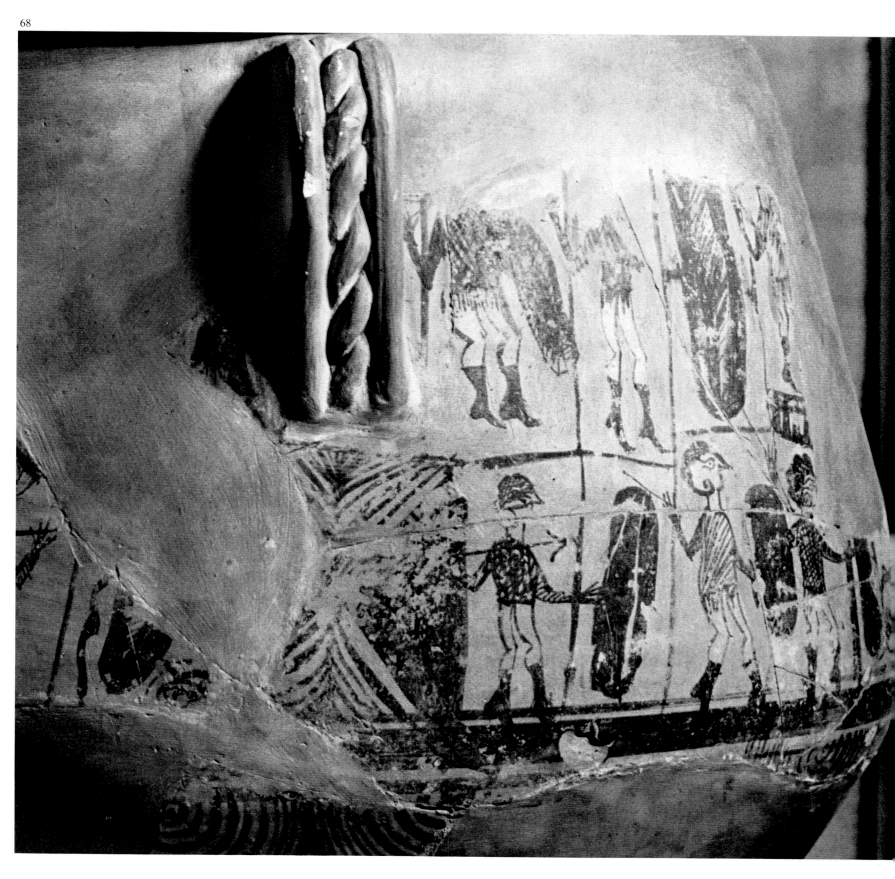

69. Detail of a painted vase from San Miguel de Liria, Valencia. 2nd-1st centuries B.C. Prehistory Museum of Valencia.

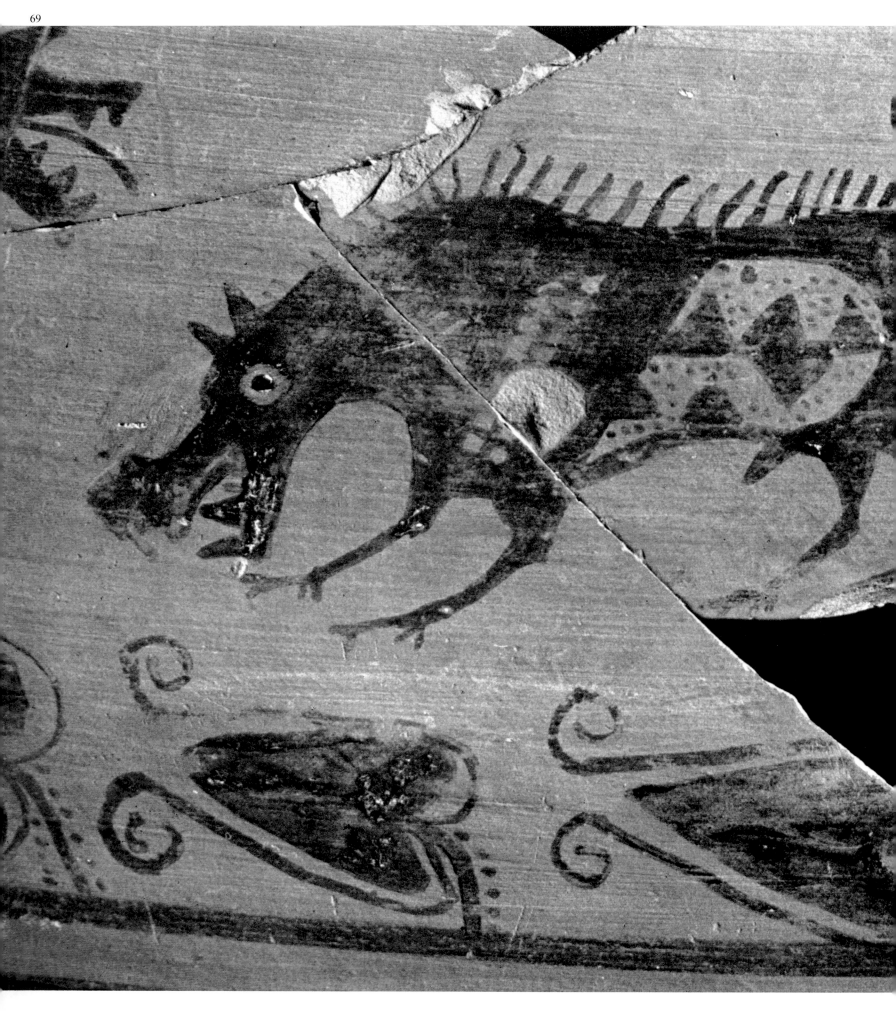

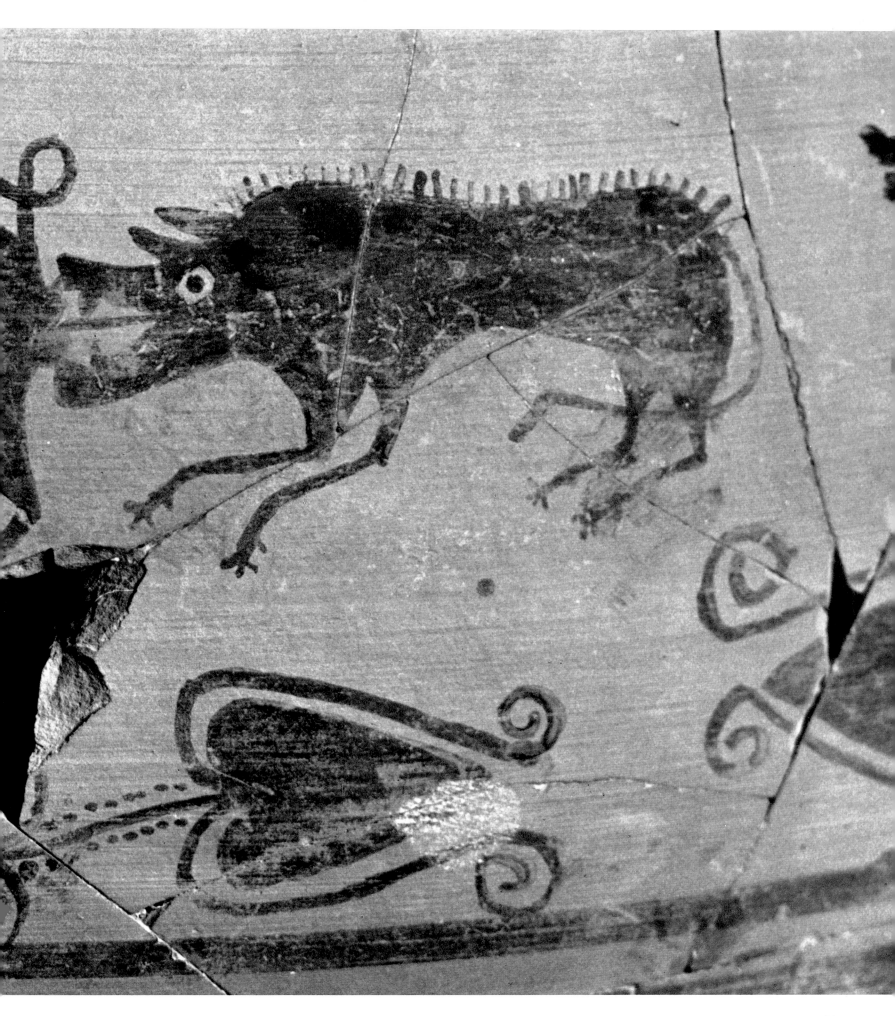

70. Detail of the painting of a vessel from the settlement of San Miguel de Liria, Valencia. 2nd-1st centuries B.C. Prehistory Museum of Valencia.

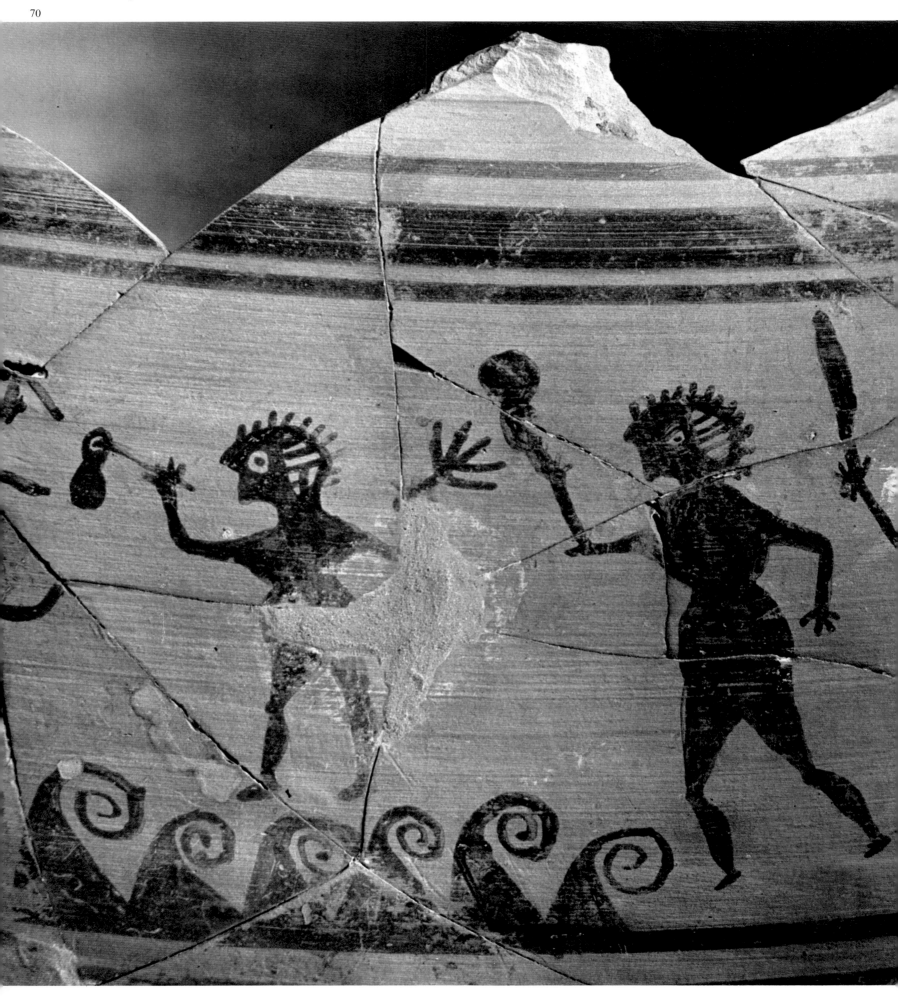

71. Detail of the painting of a vessel from the settlement of San Miguel de Liria, Valencia. 2nd-1st centuries B.C. Prehistory Museum of Valencia.

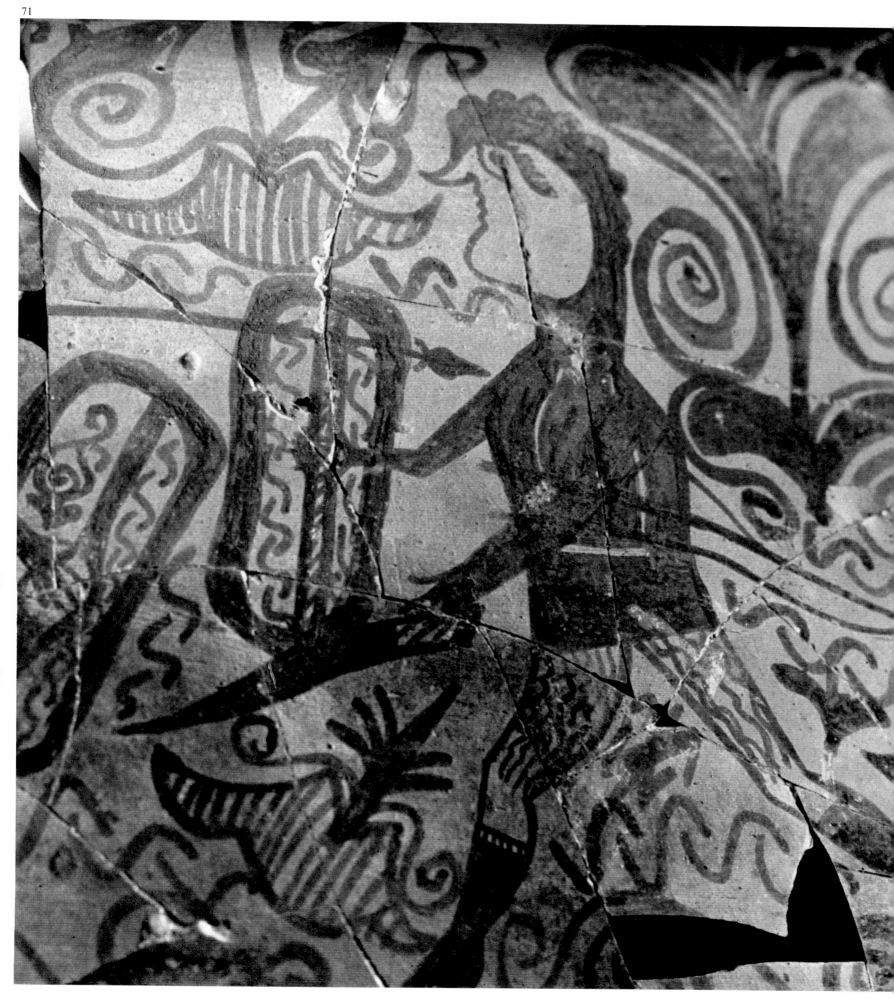

72

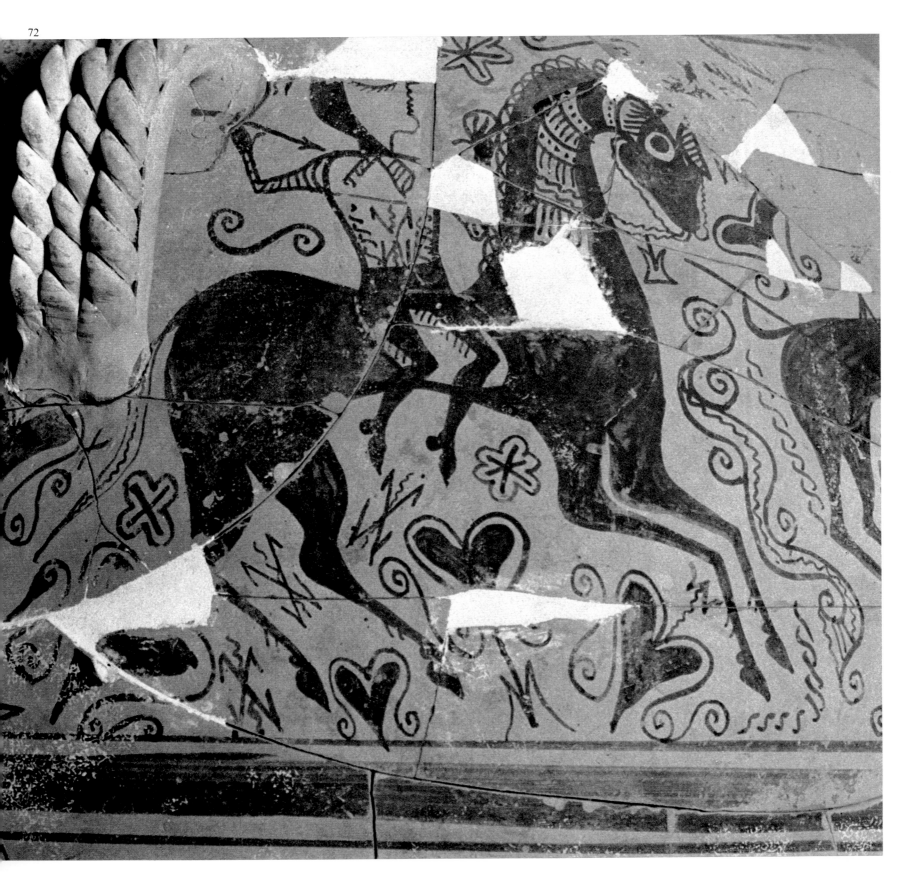

73. Rider. Bronze figurine from the sanctuary of La Luz. Murcia. Archaeological Museum of Barcelona.

74. Horseman. Small bronze from the sanctuary of La Luz, Murcia. Archaeological Museum of Barcelona.

75. Detail of the head of a horse. Stone. Sanctuary of El Cigarralejo de Mula, Murcia. Emeterio Cuadrado Collection, Madrid.

76. Rider. Small bronze from the sanctuary of La Luz, Murcia. Archaeological Museum of Barcelona.

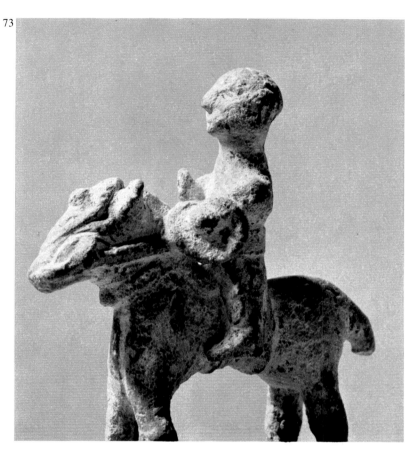

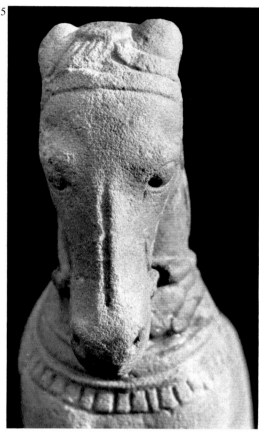

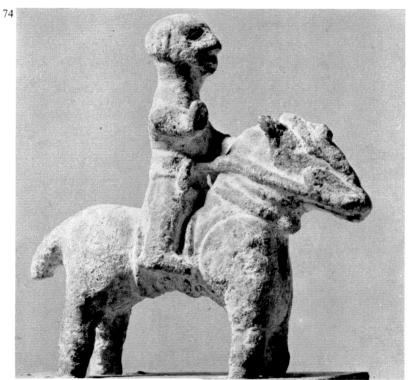

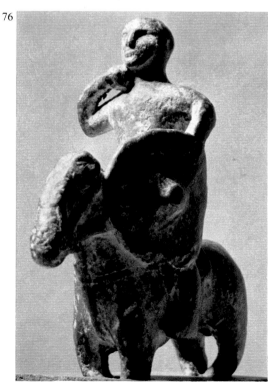

77. Bronze figurine. Rider from the sanctuary of La Luz, Murcia. Archaeological Museum of Barcelona.

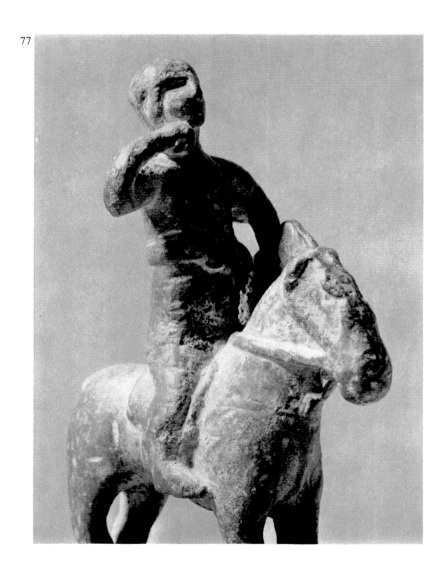

77

78. General aspect of the so-called "Great Lady," an offering figure in stone from Cerro de los Santos. National Archaeological Museum, Madrid. See details on Figs. 28 and 29.

78

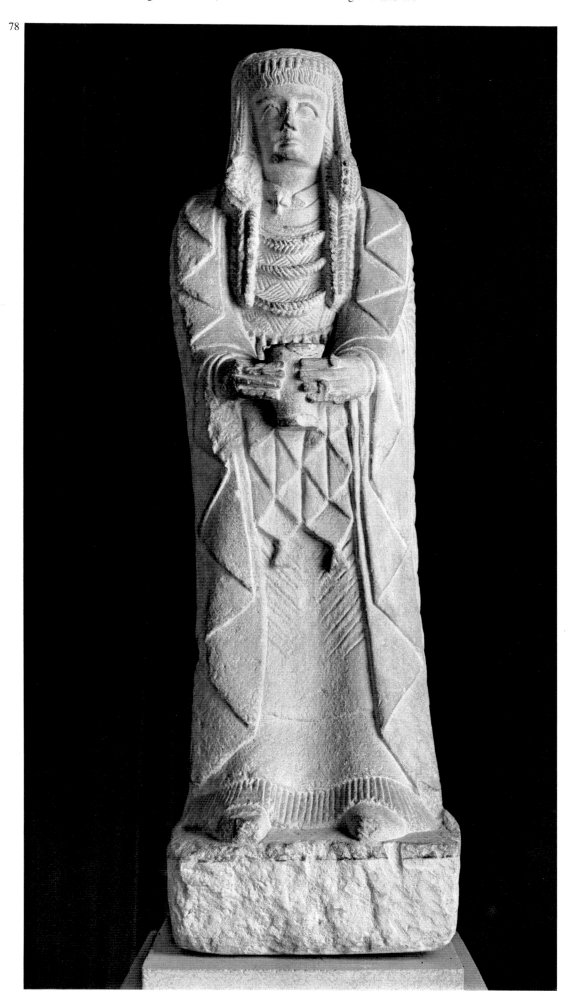

79. Relief from Almodóvar del Río, Museum of Cordova.

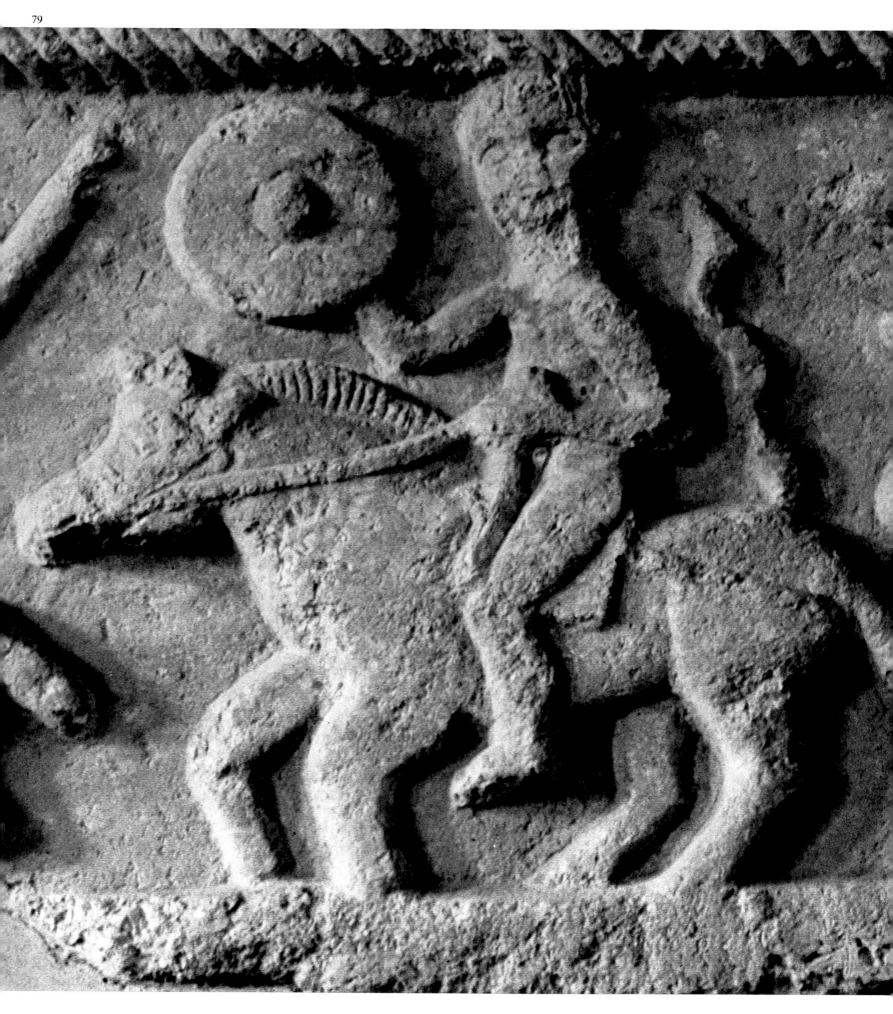

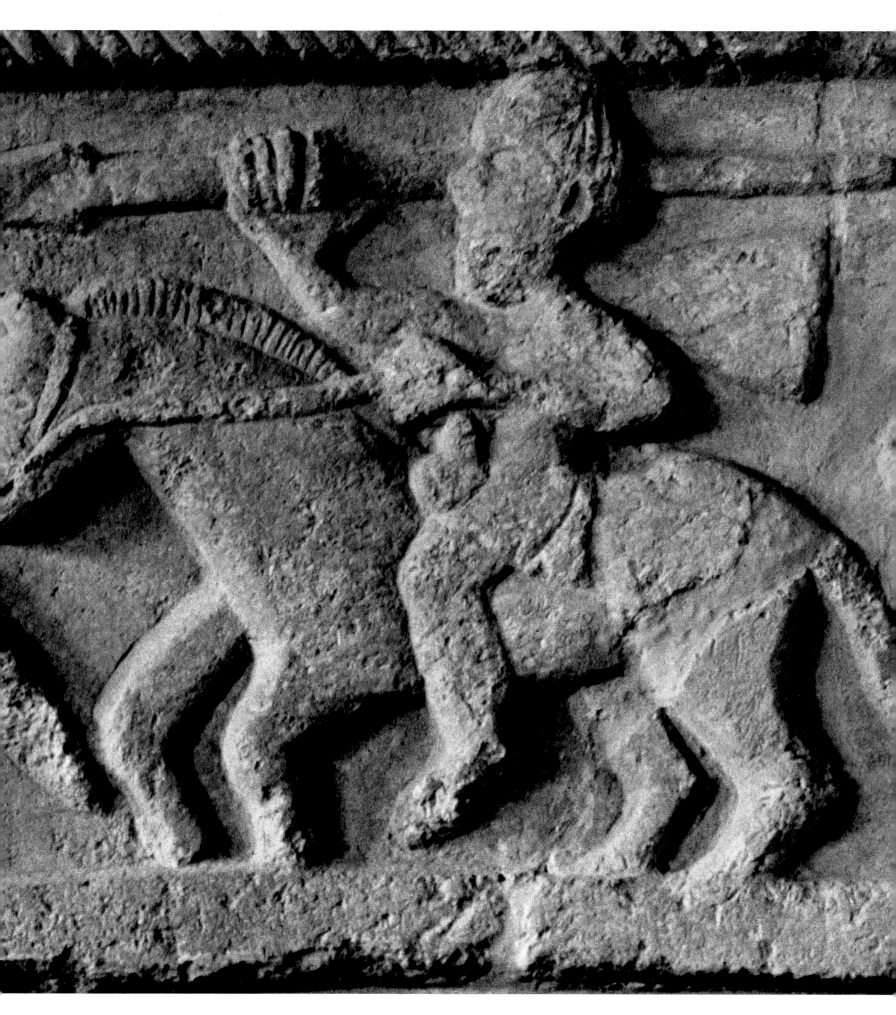

80

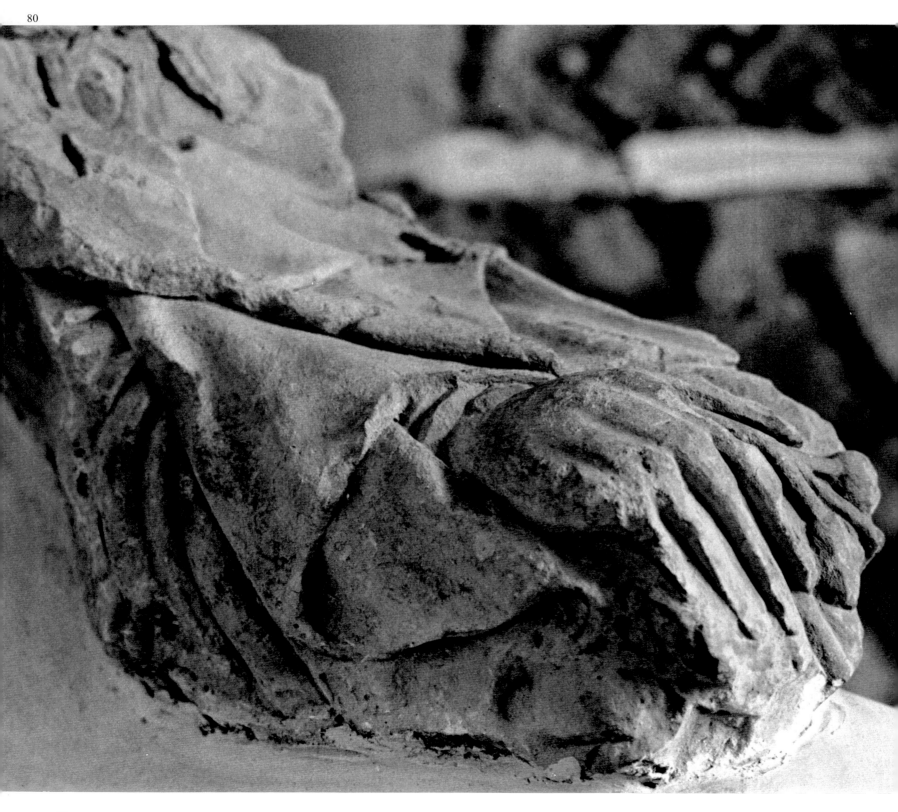

81. Fragment of architectural relief. Museum of Cordova.

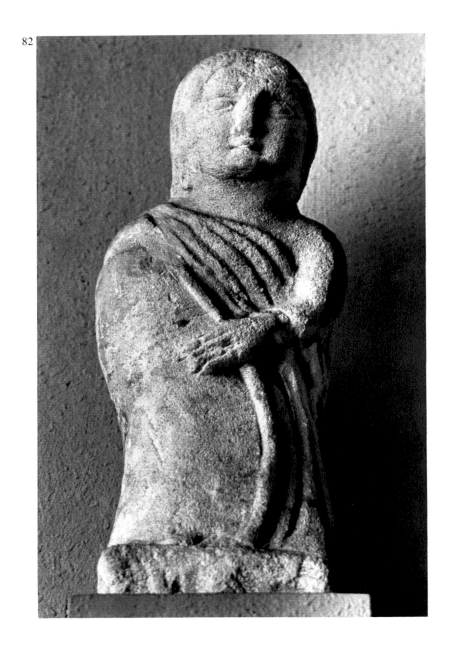

82

83. Head of a lion. Sculpture in stone. Museum of Cordova.

83

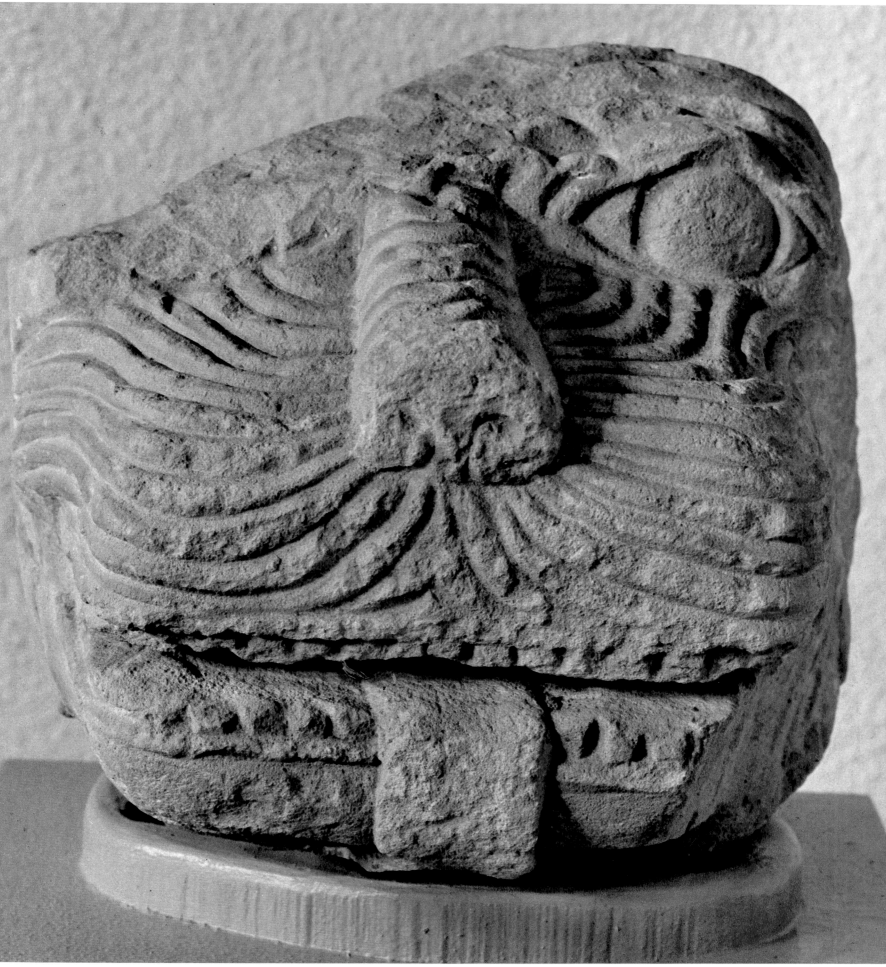

84. View of the hill of Sagunto, the site of the Iberian city.

84

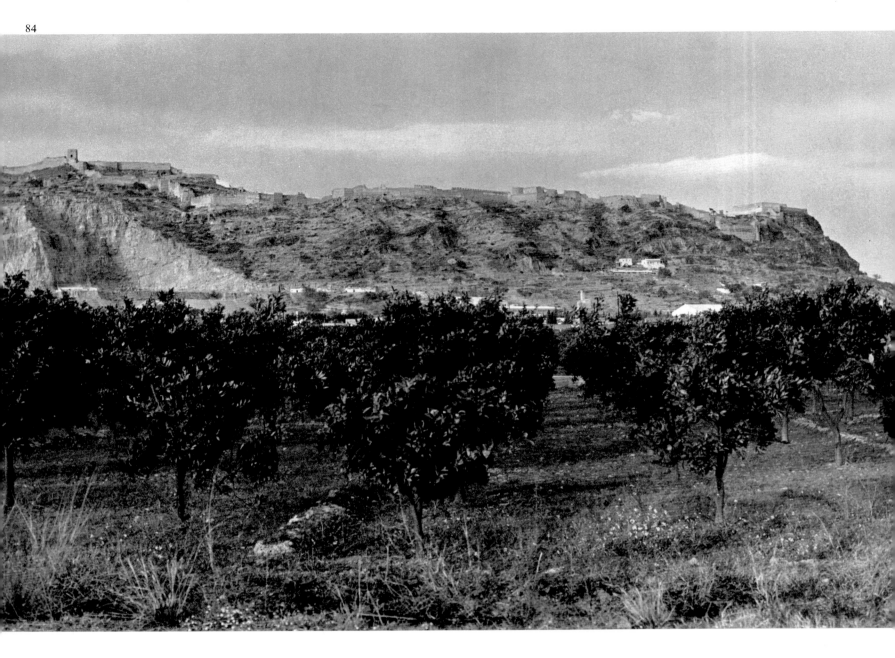

85. Female figure. Terracotta from the necropolis of La Albufereta.
Alicante. Archaeological Museum of Alicante.

85

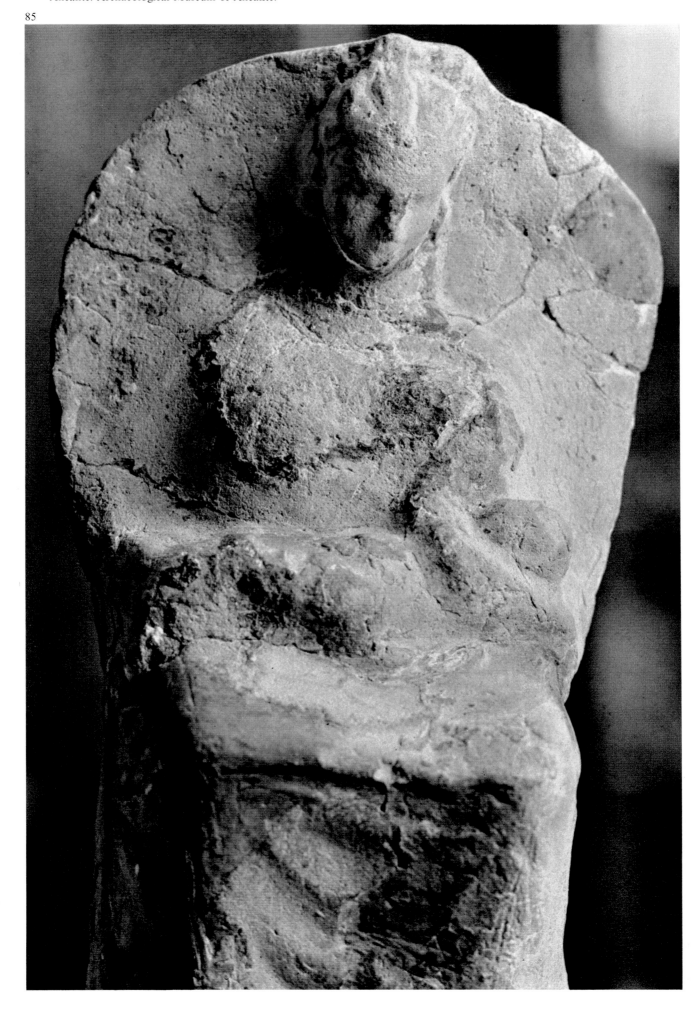

86. Body of a lion, but with the head and the extremities missing. Museum of Cordova.

87. Fragment of the head of a bull in stone, from the settlement of Cabezo Lucero, in the province of Alicante. 5th-4th centuries B.C. Archaeological Museum of Alicante.

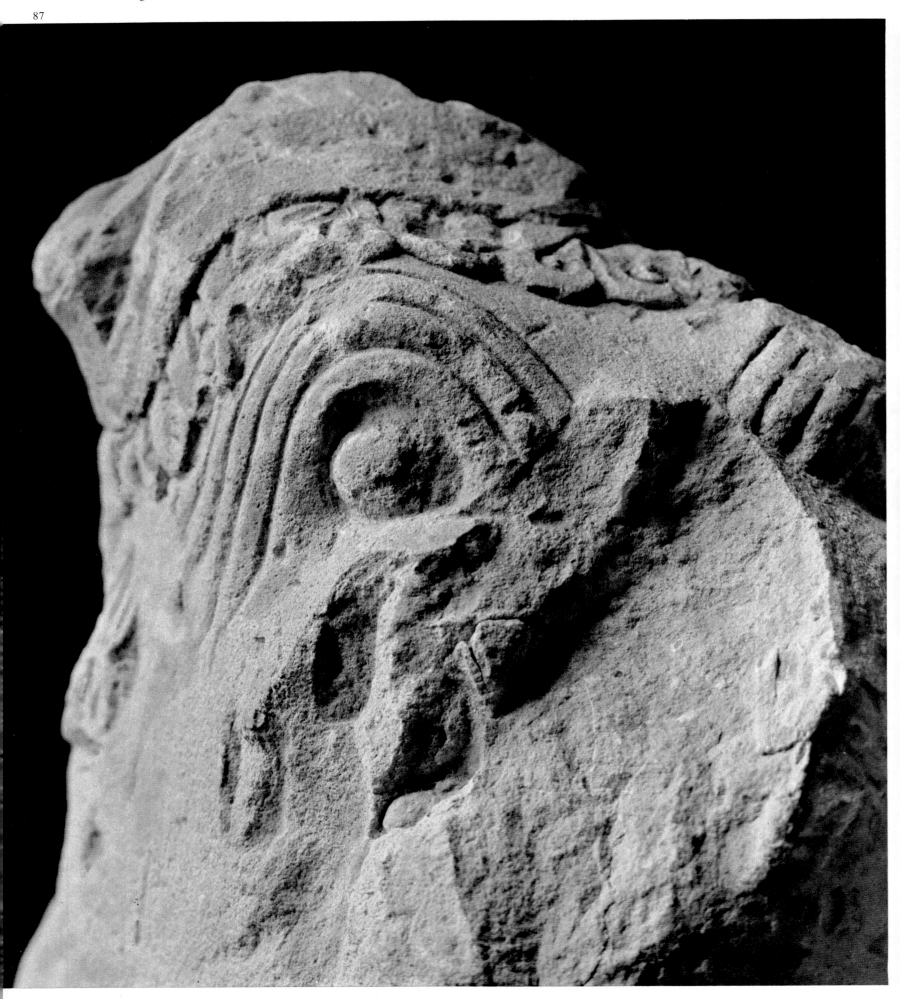

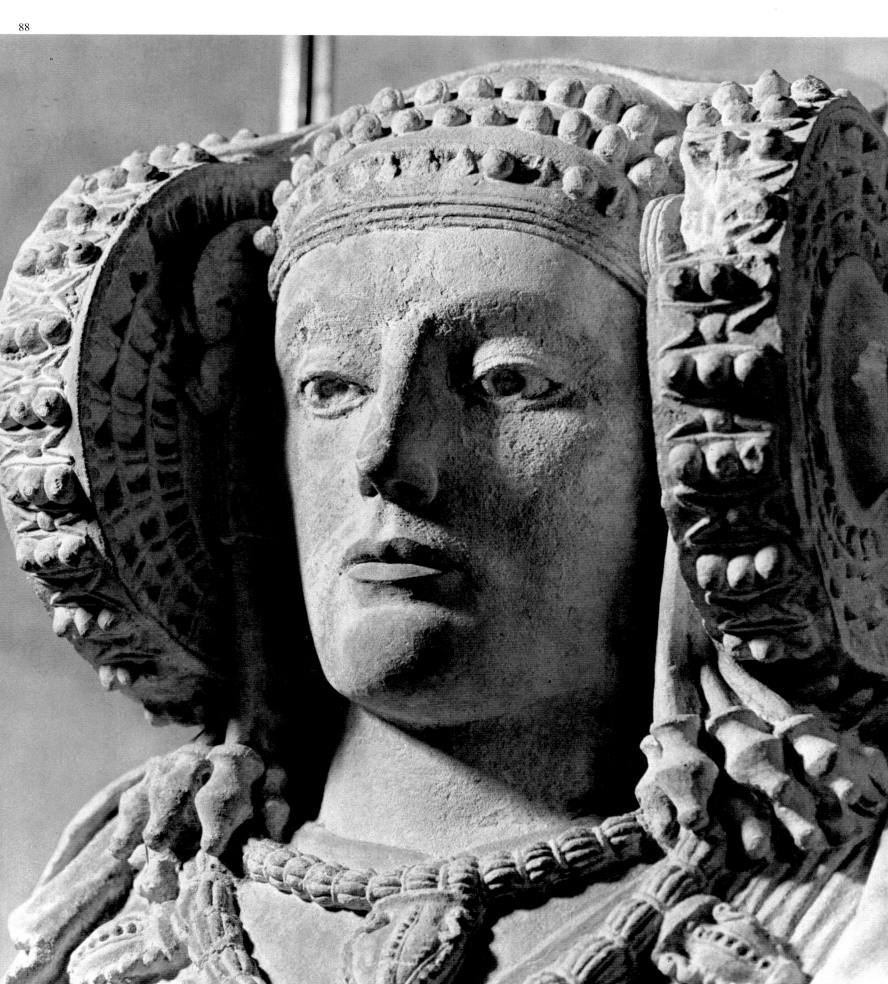

Principal centers of Iberian Art.

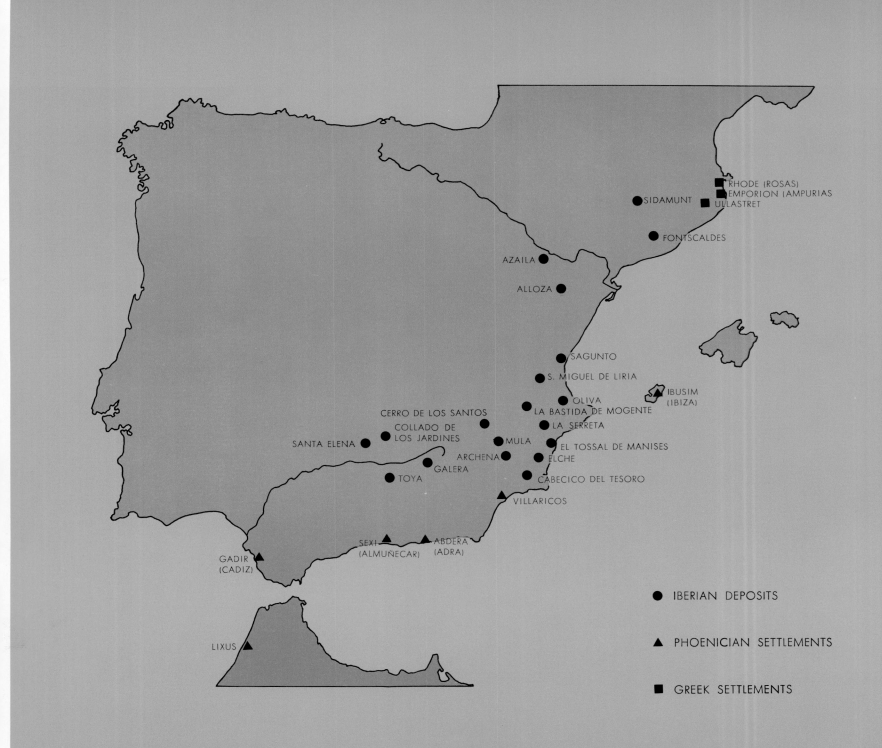

SIDAMUNT

RHODE (ROSAS)
EMPORION (AMPURIAS
ULLASTRET

FONTSCALDES

AZAILA

ALLOZA

SAGUNTO

S. MIGUEL DE LIRIA

IBUSIM
(IBIZA)

OLIVA
CERRO DE LOS SANTOS LA BASTIDA DE MOGENTE
COLLADO DE LA SERRETA
LOS JARDINES
SANTA ELENA MULA EL TOSSAL DE MANISES
 ARCHENA ELCHE
 GALERA
TOYA CABECICO DEL TESORO

VILLARICOS

SEXI ABDERA
(ALMUÑECAR) (ADRA)

GADIR
(CADIZ)

LIXUS

● IBERIAN DEPOSITS

▲ PHOENICIAN SETTLEMENTS

■ GREEK SETTLEMENTS

INDEX OF ILLUSTRATIONS

109

BIBLIOGRAPHY

a) GENERAL WORKS

Except for the work of Antonio Arribas, *Los Iberos,* Barcelona, 1965, first published in English as *The Iberians* (London, 1963), Iberian civilization is mainly discussed in works of general history. Among studies dealing with the Peninsula as a whole we should mention:

BOSCH GIMPERA, PERE: *Etnologia de la Península Ibèrica.* Barcelona, 1932. *La formación de los Pueblos de España.* Mexico, 1945. *Los Iberos.* "Cuadernos de Historia de España", IX, Buenos Aires, 1948.

CARO BAROJA, JULIO: *Los pueblos de España.* Barcelona, 1946.

FLETCHER, DAVID: *Problemas de la Cultura Ibérica.* Valencia, 1960.

MALUQUER DE MOTES, JOAN: in *Pueblos Ibéricos,* Vol. I, 3 of *Historia de España.* Espasa-Calpe, Madrid, 1954.

PERICOT, LLUÍS: *Historia de España,* Vol. I. Gallach, Barcelona, 1942. *La España primitiva.* Editorial Barna, Barcelona, 1950.

SCHULTEN, A.: *Iberisches Landeskunde. Geographie des antiken Spanien.* Strasbourg, 1955.

TARRADELL, MIQUEL: *Les arrels de Catalunya.* Barcelona, 1963. *Història del País Valencià,* I. Barcelona, 1965.

Of fundamental importance for the written sources is the collection *Fontes hispaniae antiquae,* published by the University of Barcelona under the direction of PERE BOSCH GIMPERA, LLUIS PERICOT and A. SCHULTEN.

b) SPECIFIC ASPECTS OF IBERIAN CIVILIZATION

BELTRÁN, A.: *Las monedas hispánicas antiguas.* Madrid, 1954. (Coins).

BLÁZQUEZ, J. M.: *Religiones primitivas de España. I. Fuentes literarias y epigráficas.* Madrid, 1962. (Religion).

CARO BAROJA, JULIO: *La escritura en la España Prerromana,* in *Historia de España* (Espasa-Calpe), op. cit. (Language and writing).

GÓMEZ MORENO, MANUEL: several works, collected in *Misceláneas. Historia, Arte, Arqueología. I serie: La Antigüedad.* Madrid, 1949. (Language and writing).

SANDARS, H.: *The Weapons of the Iberians.* Archaeologia, LXIV, 1913. (Weapons).

TOVAR, ANTONIO: *Léxico de las inscripciones ibéricas,* in *Homenaje a Menéndez Pidal,* II. Madrid, 1951. (Language and writing).

VIVES, A.: *La moneda hispánica.* Madrid, 1924. (Coins).

c) ART

Apart from individual chapters in the works already listed in section *a),* there are few comprehensive studies of Iberian art. Special mention should be made of ANTONIO GARCÍA Y BELLIDO's *Arte ibérico,* in *Historia de España,* Vol. III (Espasa-Calpe, Madrid, 1946, op. cit.) and the same author's chapter on the subject in *Ars hispaniae, I,* Madrid, 1946.

d) ARCHITECTURE

GARCÍA Y BELLIDO, ANTONIO: *La Arquitectura entre los íberos.* Madrid, 1945.

e) SCULPTURE IN STONE

CUADRADO, EMETERIO: *Excavaciones en el santuario ibérico del Cigarralejo (Mula, Murcia).* In "Informes y Memorias de la Comisaría General de Excavaciones", No. 21. Madrid, 1950.

FERNÁNDEZ DE AVILÉS, A.: *La escultura del Cerro de los Santos en la colección de los PP. Escolapios de Yecla.* AEArq., 1948. *Escultura del Cerro de los Santos. La Colección Velasco (Museo Antropológico) en el Museo Arqueológico Nacional.* AEArq. XVI. *Cerro de los Santos (1.ª campaña. 1962).* "Excavaciones arqueológicas en España," 55. Madrid. 1967.

GARCÍA Y BELLIDO, ANTONIO: *La bicha de Balazote.* "Archivo Español de Arte y Arqueología," 21. Madrid, 1931. *Una cabeza del estilo de las Korai áticas.* AEArq. XI. Madrid, 1935. *Arte Griego provincial. La figura sedente de Verdolay (Murcia).* AEArq. XIV. Madrid, 1940-41. *La Dama de Elche y el conjunto de piezas reingresadas en España en 1941.* Madrid, 1942.

LLOBREGAT, E. A.: *La escultura ibérica en piedra del País Valenciano. Bases para un estudio crítico contemporáneo del Arte Ibérico.* "Archivo de Arte Valenciano," XXXVII. Valencia, 1966.

RAMOS FOLQUES, A.: *La Dama de Elche. Nuevas aportaciones a su estudio.* AEArq. Madrid, 1944.

f) SMALL BRONZES

ALVAREZ OSSORIO, F.: *Catálogo de los exvotos de bronce ibéricos del Museo Arqueológico Nacional.* Madrid, 1941.

CALVO, I. & CABRÉ, J.: *Excavaciones en la cueva y collado de los Jardines (Santa Elena, Jaén).* M.J.S.E.A. Madrid, 1918 & 1919.

LANTIER, L. & CABRÉ, J.: *El santuario ibérico de Castillar de Santisteban.* Comisión de Investigaciones Paleontológicas y Prehistóricas. Madrid, 1917.

LANTIER, R.: *Bronzes Votifs Ibériques.* Paris, 1935.

g) TERRACOTTAS

TARRADELL, MIQUEL: *Catálogo de la colección de terracotas del santuario ibérico de la Serreta de Alcoy.* Museo de Alcoy, Alcoy (Alicante), 1977.

VISEDO, C.: *Excavaciones en la Serreta de Alcoy.* M.J.S.E.A.

h) CERAMICS

BALLESTER, I. et al.: *Cerámica del cerro de San Miguel de Liria.* "Corpus Vasorum Hispanorum," II. Madrid, 1954.

BOSCH GIMPERA, PERE: *El problema de la cerámica ibérica.* Madrid, 1915.

CABRÉ, J.: *Cerámica de Azaila.* "Corpus Vasorum Hispanorum," I. Madrid, 1944.

TARRADELL, MIQUEL: *Avance al catálogo de formas de la cerámica ibérica* (in the press).

List of reviews or series quoted in abbreviated form:

AEArq. *Archivo Español de Arqueología.* Madrid.
A.I.E.C. *Anuari de l'Institut d'Estudis Catalans.* Barcelona.
A.P.L. *Archivo de Prehistoria Levantina.* Valencia.
C.A.S.E. *Congresos Arqueológicos del Sudeste.* Cartagena-Zaragoza.
C.N.A. *Congresos Nacionales de Arqueología.* Zaragoza.
M.J.S.E.A. *Memorias de la Junta Superior de Excavaciones y Antigüedades.* Madrid.